More supercute CHIBIS to draw and paint

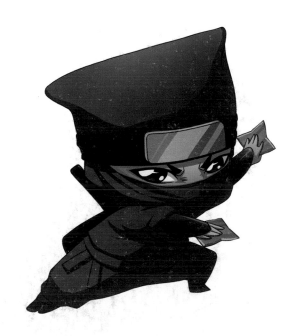

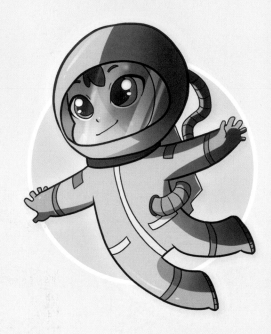

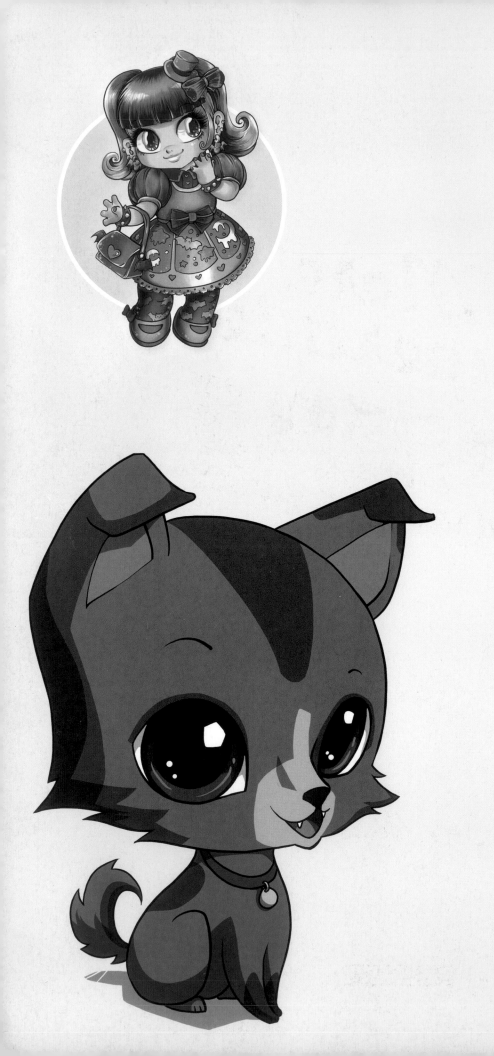

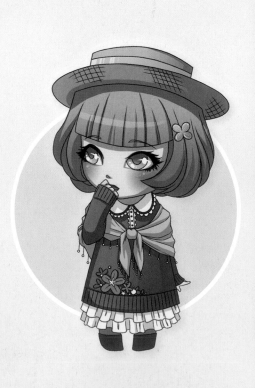

More supercute CHIBIS to draw and paint

Fez Baker

BARRON'S

A QUARTO BOOK

First edition for North America
published in 2013 by Barron's
Educational Series, Inc.

All inquiries should be addressed to:
Barron's Educational Series, Inc.
250 Wireless Boulevard
Hauppauge, New York 11788
www.barronseduc.com

ISBN: 978-1-4380-0326-9
Library of Congress Control No.
2012952828
QUAR.CCP2
Conceived, designed, and produced
by
Quarto Publishing plc
The Old Brewery
6 Blundell Street
London N7 9BH

Project Editor: Chelsea Edwards
Art Editor: Emma Clayton
Designer: Tanya Devonshire-Jones
Picture Researcher: Sarah Bell
Copyeditor: Claire Waite Brown
Proofreader: Chloe Todd Fordham
Indexer: Helen Snaith
Art Director: Caroline Guest

Creative Director: Moira Clinch
Publisher: Paul Carslake

Color separation in Hong Kong by
Modern Age Repro House Ltd
Printed in China by
Hung Hing

9 8 7 6 5 4 3 2 1

CONTENTS

This book is packed full of brand new cute characters and tutorials for you to draw. If you've already picked up a copy of *Supercute Chibis to Draw and Paint* by Joanna Zhou, then you'll know all about the appeal of chibi characters.

Chibis are a great part of the Japanese manga style because they're cute, easy to draw, and full of character. I started drawing them as fun little warm-up exercises because they're simple and great for doodling. They're also excellent for jotting down comic ideas because they're so expressive. My love for them was only increased when I started showing my art online, and I realized that there were lots of other artists out there who were also involved in the manga scene. With feedback and support from my new-found friends, and getting to see their new art whenever they shared it online, I realized that this was what I loved doing most. Hopefully, some of the tips in this book will help you to develop your own style and characters, and we look forward to welcoming you onto the scene!

On page 8 you'll find an article that explains the book's special features. Whether you read it from the beginning or just dive straight in to the character showcase, this book should provide everything you need to help introduce you to drawing chibis—whether you're still acquainting yourself with your pencils or if you're just after further tips and tricks to improve your artwork.

Good luck, have fun, and happy drawing!

Fez Baker

CONTRIBUTORS

A whole host of artists has contributed to this book, each showcasing his or her unique style. All the artists are regulars on the manga circuit, so you're guaranteed to learn from their expertise!

Sonia Leong
I'm a U.K.-based professional Manga artist with many years of experience in comics, art books, children's books, magazines, and more. Chibis are so cute and fun to draw, I love putting them in all of my work, sneaking them in whenever possible and drawing portraits of friends and family in chibi-style!

Carly Matlack
Chibis are a cute and fun way to exaggerate characters. Currently, I am a freelance artist working from home, which is in New Millport, Pennsylvania.

Nina-Serena
I'm Nina-Serena, a freelance artist currently residing in England. I work in a multitude of styles but Japanese Chibis certainly hold a special place in my heart; they are the ultimate artistic expression of cuteness!

Laura Watton-Davies
I love drawing chibis because they are simple to create (once you get the hang of it) and they bring a lot of fun and color to any scene! I'm an illustrator, comicker, and game artist, living in Cambridge (U.K.). I have illustrated chibi characters in works published by Tokyopop, Neo Magazine, Sweatdrop Studios, and more.

Sammi Guidera
I love everything that's cute, and chibi characters are just that—adorable and expressive! I'm a manga-loving, comic-drawing freelancer living in Los Angeles.

Sally Jane Thompson
I am a comic creator and illustrator and came to comics through reading manga. Though my artwork is not generally chibi, it bears a continued influence from chibis' vibrant fluidity and expressiveness. My work has appeared in publications from IDW, Image, and Rockport Publishers, as well as in my own self-published comics.

Heather Sheppard
I am a freelance comics, games, and film artist living in Leamington Spa (U.K.). I like to draw chibis, especially when I need a bit of cheering up!

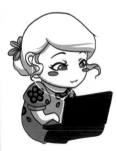

Kit Buss
I am a comic artist and illustrator from Cambridge, U.K. I tend to draw a lot of serious things in my work, but I love drawing chibis, too—they're an adorable and expressive way to draw great characters!

ABOUT THIS BOOK

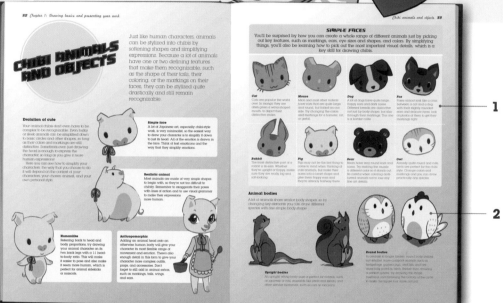

Drawing basics and presenting your work, pages 10–39

This part takes you through the basics of drawing chibis, from choosing media to how subtly altering the position of the facial features can completely change a character's expression and amplify its cuteness.

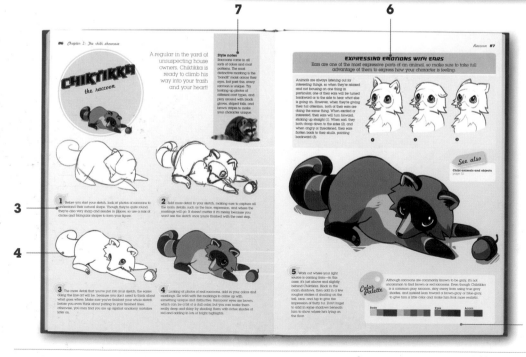

Chibi showcase, pages 40–125

The chibi showcase features step-by-step instructions to help you create a wide variety of fun chibi characters. The works are by a range of artists, so you'll be able to see different styles on offer.

1 Acquire conceptual and practical tools—learn how to think like a chibi artist.
2 Specially drawn and colored examples that demonstrate elements in the text.

3 Each stage of the image, from sketch to final coloring, is detailed with clear text and illustrations.
4 Trace this! In each sequence, there is always one stage that you can trace or scan.

5 Color palettes let you see why certain color schemes work well.
6 Poses, expressions, body language, costume: lots of the things that occupy chibi artists are explored in these panels.

7 Style notes offer background to how the artist conceptualized the character.

Cute, full of character, and simple to draw, chibis are the perfect subject for newcomers to manga, and a fun diversion for those who have been drawing them for years. Drawing chibis is a great way to learn the fundamentals of the style, and the basics of drawing and design.

With their big heads, exaggerated expressions, and simplified bodies, chibis are instantly recognizable. These characters originated in Japan in manga books as a simple, exaggerated way to show humor or emphasize jokes, but have since proven so popular that they've influenced art and designs in many other areas, such as video games, children's toys, and animations.

Full of artwork and tips from professional artists from all over the world, this book provides step-by-step tutorials to get you started drawing chibis, from finding the right tools to designing your characters, and maybe even turning your drawing into a full-time career.

Style

If you're more interested in designing outfits and fashion, chibis make great models for showing off your designs (see page 108).

Materials

You're not restricted to just drawing cute characters in pretty dresses; you can capture reflective surfaces and mix them in with familiar fabrics (see page 50).

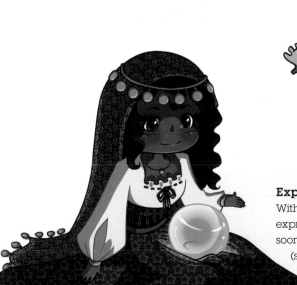

Expression

With a little practice in drawing expressions and adding in color, you can soon learn to draw characters like this (see page 120).

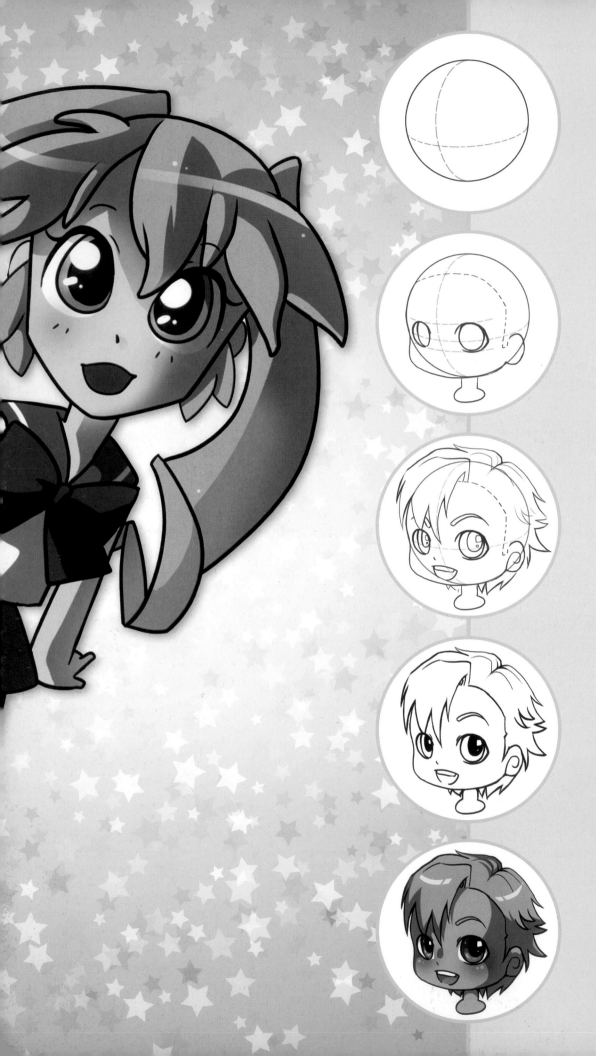

1

DRAWING BASICS

and presenting your work

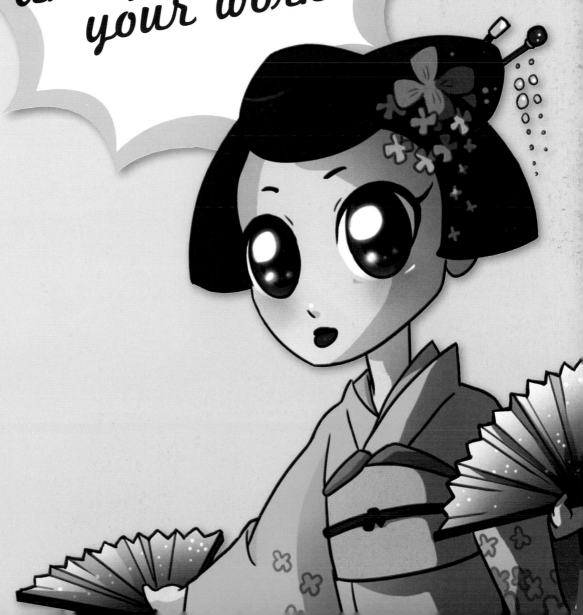

TRADITIONAL MEDIA

If you're just starting out as an artist, chances are that you won't have much in the way of art materials or digital equipment at hand, but never fear, a traditional media beginner's kit is inexpensive, and you'll be likely to find some of it already lying around the house.

"Traditional" media generally counts as anything that you apply directly to paper—for example, coloring pencils, watercolor paints, and markers. Using them can seem restrictive, in that there's little chance to change your color choices later on, and fixing mistakes can be difficult, but the final product is a lot more personal, and producing something by hand can feel a lot nicer than doing so on a computer. Be sure to practice before you start, and even consider making copies of your work before you begin.

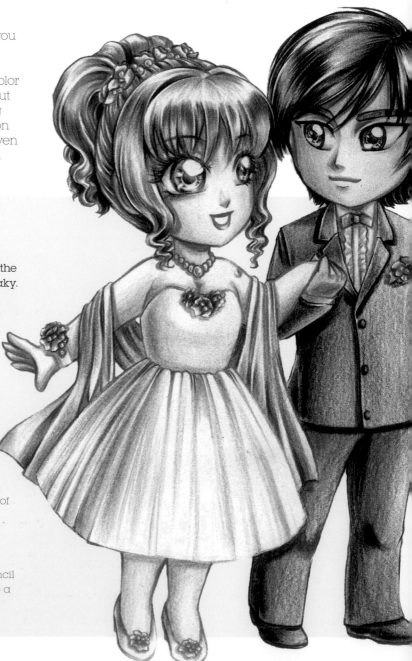

Colored pencils
You may already have a pack of colored pencils nearby; if not, they are inexpensive and easy to find. Keep them sharpened, and use the sharp tips for colored line art and the long edge for coloring, to stop the image from looking streaky. Don't press down too hard because if you do you won't be able to layer other colors on top. Try layering richer, more vibrant colors on top for a really bright finish.

Flat color
When putting down flat colors, use the broad side of your pencil to avoid any visible pencil lines.

Highlights
To create highlights, use fast, smooth strokes and a number of different shades to create a smooth gradient of color.

Line art
Try using a darker colored pencil for your line art, as opposed to a black pencil or pen. This will soften up your lines.

Watercolor paints

Watercolor paints are another cheap and accessible medium to try. All you need is one large brush for color washes, a smaller brush for details, and a basic set of paints. There are several different techniques you can try, so why not play around with different painting styles?

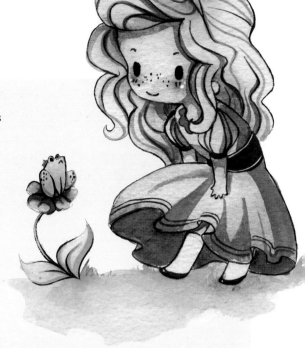

Wet-on-wet

For a wet-on-wet style, dampen areas of your image first, then add the colors that you want. This will give an even color. Watch out, this can make your colors run, so keep a piece of paper towel on hand just in case.

Wet-on-dry

For details, you can try using a wet-on-dry technique. Applying wet paint onto dry paper will ensure the paint stays exactly where you put it. Make sure that any previous paints have dried first. You can use blotting to add texture or lighten colors you've put down. After applying paint, use paper towel to dab color off where required.

Spatter effect

Another great way to add texture is to tap your brush on your finger to create a spattering of paint across your image. Cover areas that you don't want spattered before you start, as it could get messy!

Marker pens

A favorite with traditional artists and graphic designers, alcohol-based marker pens are different from felt tips in that they create areas of smooth, nonstreaky color. They can be blended or layered to create new colors, and you can also buy special pens for your line art that won't be smudged by marker ink. Many companies sell white ink for correcting mistakes, or you can use a white gel pen or acrylic paint.

Uniform coverage

Use fast, even strokes to get a smooth, consistent color with marker pens.

Blending shades

Most marker sets will come with a blender pen. Use this to make sure that your colors blend seamlessly into each other.

Line thickness

You can buy sets of marker-specific fineliners that won't bleed when you color over them. These usually come with a range of different nib thicknesses.

It can be quite expensive to get started using digital media, but if you're confident that you want to continue drawing, either as a hobby or professionally, it's worth it in the long run. However, if you're smart about it, there are plenty of free programs out there, as well as inexpensive equipment, which you can use until you know whether it's for you or not.

Digital art looks great in print, and is generally more popular in the commercial industry. You'll need a combination of different hardware and software to get started.

Some people think that using digital media will instantly make you a better artist. Sadly, this isn't the case. You'll still need to put in plenty of practice, but most graphics programs will offer you an array of new techniques, styles, and even brushes that mimic traditional media, so you'll have plenty of creative ways to express yourself.

Laptop, desktop, or tablet?

If you're looking to buy a computer for drawing, it's difficult to know where to start. If you travel a lot, or don't have very much space, a **laptop** is ideal. However, they can be expensive, and the monitors aren't ideal for drawing because they often don't show colors or contrast very accurately.

A **desktop** computer, if you have the space for one, is ideal for drawing. They're cheaper than laptops, and the monitors are great for checking that your colors are right: you can also upgrade your graphics cards, monitor, and RAM every few years instead of having to buy a completely new computer.

Tablet devices are cheaper than both laptop and desktop computers, and there are quite a few free or cheap graphic applications that you can download for them. However, the screens can be small and quite difficult to draw on, and printing your work can be tricky without first transferring it to another device.

When using a tablet device, you can draw with a finger; however, you may find it easier to use a stylus instead. While most styluses (and tablet devices) don't have pressure sensitivity like a traditional graphics tablet, a stylus does give you greater accuracy, more comfort, and a way of keeping fingerprints off your screen. It can take a little practice to get used to—as will any medium—but it is worth the investment. Tablet styluses vary greatly in price, so it is always best to read some reviews on

It's free!

GIMP This is one of the most popular open-source graphics programs. Completely free to download, its interface is a little cluttered but it has all of the tools that are available in professional graphics programs.

Inkscape If you want to create vector drawings, Inkscape is an ideal piece of free software to use instead of more expensive programs.

Oekaki If you have a good Internet connection, another great way to practice your digital drawing is to use oekaki programs. From the Japanese word meaning "to doodle," oekaki programs are like online forums with built-in, basic art programs that help you to share your own work and comment on the work of other people.

Spend a little

If you're willing to spend a small amount of money on software, there are plenty of small-budget programs out there, such as Paint Tool SAI, which is very popular with digital artists, or Manga Studio, a commonly used program for creating manga artwork. ArtRage and openCanvas are also extremely popular and very affordable, and there are earlier versions and tablet versions of the programs on their web sites that are free to download. Some programs even come with a free trial.

Apps for tablet computers

If you're using a tablet computer, you might want to browse through available app downloads and try out the free programs. Free or affordable apps that you might come across include ArtRage, Sketchbook Pro, ArtStudio, Brushes, and Inspire Pro.

Shading

Shading is a key part of a drawing, as it helps make an image look three-dimensional. You should never shade with black, gray, or brown because this muddies your colors, but instead experiment with warm tones such as red or orange, or cool shades, such as purple or blue, to add mood lighting.

There are plenty of different styles in which you can add in shading, be it in a soft, more painterly way or in the traditional, animation-style cel-shading.

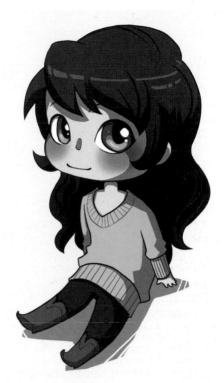 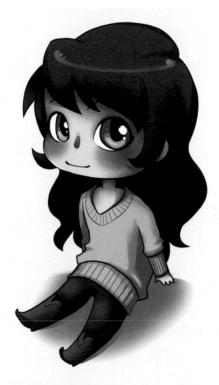 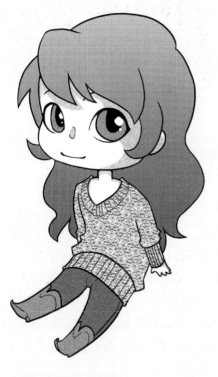

Cel shading

Cel shading consists of plain colors with clear, defined outlines and solid blocks of shade. It mimics the kind of shading used on cels in animated TV shows and movies. It can sometimes look too harsh or heavy on a picture, but it's one of the quickest and easiest ways to color, and you can easily change how dark it looks afterward.

Soft shading

Soft shading has a nice, smooth effect that looks more like painting than digital art. You'll need a pressure-sensitive graphics tablet to blend your colors smoothly, and a program with a soft brush or airbrush setting. You can try mixing soft and cel shading to add definition and shape to your image.

Digital screentones

Screentones are the most common form of shading seen in manga. Traditionally, sheets of screentones are cut to shape with a knife, which can be expensive, tricky, and hard to get right. However, if you want to try using this effect, you can find scans of screentone sheets online and apply them digitally. Screentones are only made of black and white dots or lines, which emulate different shades of gray.

the most up-to-date styluses, and make sure you check for compatibility with your tablet device.

Graphics tablets

A graphics tablet is essential for any aspiring digital artist. They are available in sizes from 4 x 5 in. (10 x 13 cm) up to 9 x 12 in. (23 x 30 cm) and larger. The smaller ones are the least expensive, and are ideal as an introduction to graphics tablets.

The most useful ability a graphics tablet will give you is pressure sensitivity. Unlike using a mouse, the nib of a graphics tablet pen can tell how hard you're pressing down on it, and adjust the thickness, opacity, and even colors of your line accordingly.

Graphics tablets don't have to be expensive, because there are plenty of companies producing inexpensive equipment, and some even come with graphics software included. You can also find good tablets for sale secondhand because they last for years and are often replaced, not because they are faulty, but because the owner is upgrading to a new one.

Scanners

If you're used to drawing by hand but want to try your hand at working digitally, buy yourself a scanner so that you can scan in your drawings and practice digital coloring. You can generally buy flatbed scanners relatively cheaply; and nowadays a lot of printers come with a scanner combined, so if you're thinking of printing your artwork, this could be a good option for you.

BASIC DRAWING TECHNIQUES

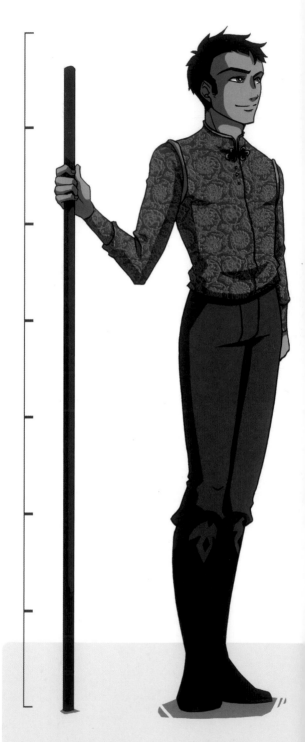

Chibis are certainly easy to recognize, but what is it that makes them so distinctive? Chibi is a Japanese slang term for a small person or child, though since its adoption into the manga art scene it has become synonymous with something that is both small and cute. As a result, chibi characters are rarely taller than three heads tall, which means that a chibi head takes up a whole third of the figure.

Other distinctive features include the particular way that they are often simplified. For example, some details such as noses, fabric effects, and even fingers are completely omitted, whereas others are made larger for a cute effect, such as eyes, buttons, accessories, and clothing patterns and details.

As a standard, chibis are often between two and three heads tall —as opposed to realistic proportions, where the average person can be drawn as between six and eight heads tall. Chibis are sometimes as tall as four heads high; however by this point they can start to lose their look a little, so make sure you retain the other elements of their style, such as their big eyes and exaggerated expressions.

Body basics

If you are used to drawing "normal" people, drawing in exaggerated chibi proportions can feel strange at first. Start by sketching the head because this is the largest part, then measure out how tall the body should be from there. This way, you'll be able to focus on loosening up your style rather than constantly measuring to make sure what you're doing is right.

There's no set rule to what your own style of chibi should look like. Be creative and experiment with different head-to-body ratios, body shapes, and levels of detail. Because there's a lot of freedom within the chibi genre, take the chance to really develop your own style.

Standard proportions
The drawing above shows a figure with normal proportions. He is seven heads tall, which is relatively average for most people.

HEAD·TO·BODY RATIOS

This simple guide illustrates how using different head heights to measure your figures affects the look of a character.

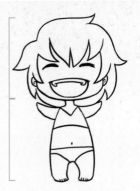

Small, simple, and super cute, this chibi's body is the same size as her head, which makes her really easy to draw, but you've got to be clever when simplifying the details.

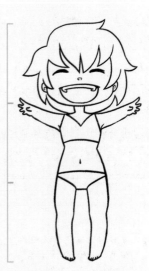

The most common head-to-body ratio for a chibi character is 1:2. With these proportions, the character is small enough to still be cute and appealing, yet versatile enough to really show a range of personality and emotion.

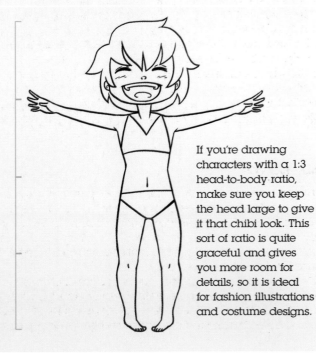

If you're drawing characters with a 1:3 head-to-body ratio, make sure you keep the head large to give it that chibi look. This sort of ratio is quite graceful and gives you more room for details, so it is ideal for fashion illustrations and costume designs.

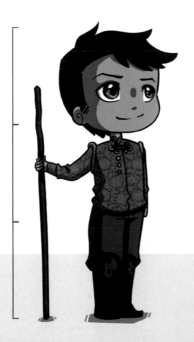

Chibi proportions

The same character is drawn again here, though in a 1:2 head-to-body ratio. Note how his pose, clothing, and expression are the same as before, but he looks instantly cuter.

Drawing heads

The head and face are by far the most important parts of your drawing. People connect best with other people, so if your faces are in proportion, people will be drawn to your art and your characters. You can still experiment with your own drawing style, but it's important to learn the basics first.

How to draw the head

1 Sketch out the shape of the head with a rough circle. Draw a cross-shaped guideline over the top, following the curves of the circle, to indicate which way your character is facing.

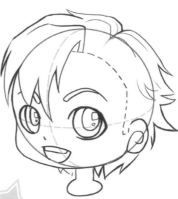

2 The eyes are the most important part to get right, because they'll give your character personality and life, so tackle them first. Draw them across the horizontal axis of your cross guideline, drawing two more rough guidelines above and below to make sure that both eyes are the same size. Draw in your face shape and, if it helps, draw in the hairline too.

3 Add in a few more facial features, such as the mouth, nose, and hair. Use your circle to make sure that the head keeps its shape: hair has lots of volume, so don't draw it right up against the skull.

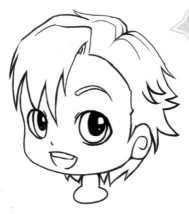

4 Once you are happy with how everything looks, outline your sketch. You can do this with a pen and erase your pencil lines, or scan it and add the lines digitally. Alternatively, if you're drawing straight onto your computer, create a new layer and draw the lines on this, then erase your sketch.

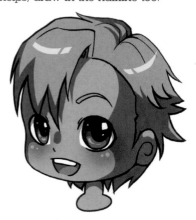

5 Fill in your flat colors, making sure that you're happy with the color scheme before you shade it. Then add the details, such as highlights in the hair, a blush and shine on the cheeks, and extra highlights in the eyes.

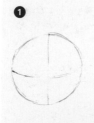 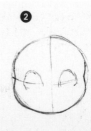 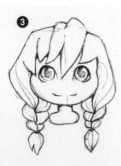

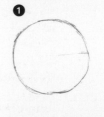 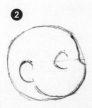 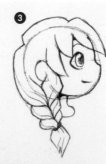

Front view

(1) The size and shape of the head never changes, no matter which angle you're drawing it from, so always start with the same circular shape. Keep your guidelines centered for a front view, but remember to still give them a slight curve, because you're still drawing onto a round object.

(2) You might have some difficulty making the face symmetrical, but don't worry, it's one of the trickiest parts to do when drawing from the front. Use extra guidelines if you need to.

(3) If you're really having difficulty getting everything to match up, draw just one side of the face, then use a light box to flip and trace it, or alter it digitally by copying sections of the sketch and flipping them over.

Side view

(1) When drawing a side view, you only need to draw the horizontal part of your axis. Tilt this up or down, depending on where your character is looking.

(2) Draw the shape of the face by tucking it in a little from your circle guideline. Because chibis are cute and rounded, try to avoid any sharp edges on your nose tip and chin. You can omit the shape of the lips as well if you like.

(3) The eyes are a slightly different shape from the side, so be aware of this. Draw them centered over your horizontal axis to get them in the right place, which should be on the same level as your character's ear and the bridge of its nose.

Shading faces

Before you start to add in areas of light and shadow, think first about where the light in your image is coming from and what sort of atmosphere you want to have. Lots of heavy, dark shadows can make an image sinister or threatening, whereas light, brightly-colored shadows can make the image look warm and bright.

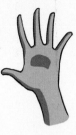
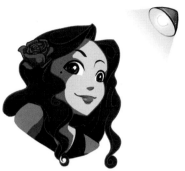

Light from the right
Demonstrate the direction of light by shading the eyes and around the curve of the cheeks, and draw in any shadows that fall from the hair.

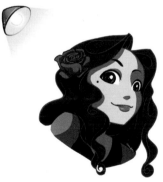

Light from the left
Draw your shadows around the shape of the face, keeping in mind that, even though the nose is drawn simply, it still casts quite a large shadow.

Light from behind
Be careful with more dramatic lighting angles because they can look creepy or quite drastic, which is great if that's what you're going for! Try experimenting to see what sort of atmospheres you can come up with.

Drawing hands

If you've tried drawing them before, you'll know how difficult hands can be to get right. Luckily, you have two of your own to practice with! The chibi style allows you to simplify hands if you struggle with them, but it still helps to understand the basics of how they bend and look. Start by making sketches of your own hands in different poses, then try simplifying them.

Realistic hands
If you're drawing more realistic hands, keep in mind that each finger has knuckles, joints, and nails. The wrist is well defined and the muscles in the palm give it shape.

Simplified hands
This is the most appealing way to draw chibi hands. Details such as the nails and the shape of the wrists are omitted, but they're still cute and quite delicate.

Mitten hands
The mitten style is also quite popular with chibi artists. The forefinger and thumb are drawn in to indicate the hand gesture, but the rest of the fingers are drawn together with only slight definition.

No hands
If you're drawing your characters really simplified, you can always omit the fingers altogether! This is an effective way to draw if you want the viewer to focus somewhere other than at what your character's hands are doing.

Drawing feet

Drawing feet in a simplified, chibi style is great for practice because you have a chance to get used to the shape of them without having to worry about the tricky parts, like the toes.

Feet shapes
In the most basic way, a foot is composed of a triangular shape; you can flick the end of the foot up a little to suggest toes (1). To make feet three-dimensional and really add some life to your poses, try picturing them as a wedge shape (2). As with hands, practice drawing your own feet from different angles, then start simplifying them (3).

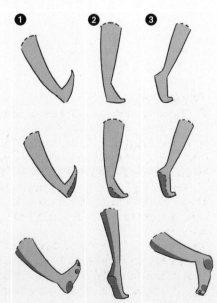

Visual grammar of expressions

Expressions are mainly written in the eyes and brows, but you can add other elements to exaggerate them, such as adding blushes, dramatic shading, and tears. You can also use graphical information such as exclamation marks and breath marks to get the point across. These kind of visual markers are used frequently in manga.

 Happiness Show rays of sunshine.

 Dizzy Angular, spiraling eyes express dizziness.

 Love Add a little heart and a blush.

 Crying Use flat eyes and tear trails.

 Tipsy Try drunken bubbles and a blush across the nose.

 Angry Draw big, angular eyes and a temple vein, and add an angry scribble above the head.

 Embarrassed Add a drop of sweat and an embarrassed blush.

 Sighing Show closed eyes and a little sighing breath.

 Shocked Big eyes, a wide mouth, and lines of surprise express shock.

 Confused Blank eyes and a question mark express confusion.

 Surprised Add an exclamation mark of surprise.

 Want Use huge shines in the eyes and a wide mouth.

 Asleep Show flat eyes and a drooling mouth.

 Being cute Add big, sparkling eyes and a cute blush.

Eyes and expressions

The basic eye is almost always the same shape, but once you've got the hang of it, you can experiment. The eye consists of the iris, the pupil, and lots of highlights. These three components should always be used to give the eye depth and character. Just as important as the eyes are the brows, which emphasize expressions. Particular care is needed when drawing eyes because even the slightest asymmetry can make the face appear lopsided.

Drawing and coloring eyes

A common misconception about manga-style art is that eyes always look the same. In fact, the eyes are possibly the most flexible feature of the entire character: their size, shape, and style defines the character. This tutorial shows how to draw and color a basic, round chibi eye, although you can experiment as much as you like once you feel confident enough to do so.

1 Start by sketching an oval shape, but with the base slightly flattened. This is your basic eye shape.

2 Darken and bring out the lines to one side a little. This shows where the eyelashes will go, because they tend to clump together on the farthest side of the eye. Even men have eyelashes, so don't forget them! Draw in the iris to show where it will be pointing.

3 Finish up your sketch by adding in the pupil, which will be larger or smaller depending on the expression you're drawing. Don't forget to mark in where the light is coming from, as it reflects in the eyeball.

4 When inking, remember to emphasize the top and bottom of the eye, to show the eyelashes. Remember to leave the light reflections uncolored.

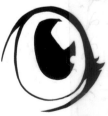

5 When coloring, the iris generally gets darker toward the top. Use rich colors to make it look deep and appealing. Don't forget to add a slight blue shadow to the whites of the eyes to make them three-dimensional: eyes are like water in that they reflect their surroundings, so avoid using gray or brown to shade. Add some extra highlights to make the eyes really light up.

EYE VARIATIONS

Once you know how to draw a basic eye shape, there are hundreds of possibilities out there. Different eye shapes, sizes, and colors add character and personality to your characters.

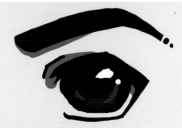

Masculine eye Male eyes are very square, and should have strong brows and solid lines.

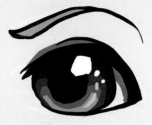

Unisex eye A slightly softer but not overly rounded eye could belong to either a male or a female.

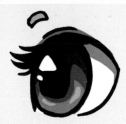

Feminine eye Thin brows, thick eyelashes, and lots of highlights make an eye feminine.

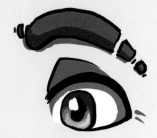

Older eye Older characters tend to have thicker brows, as well as heavy lids and slight wrinkles around the eyes.

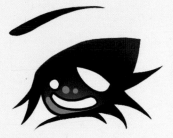

Fantasy eye Your fantasy characters can have all sorts of eyes, from different-shaped pupils to lots of crazy colors!

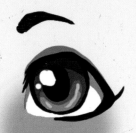

Excited eye When people are excited, their pupils get smaller and the eye widens. Don't forget a happy blush.

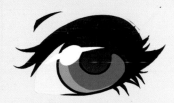

Flirtatious eye When flirting, the eyes narrow out a little and the pupil widens. A touch of makeup makes it more playful.

Serious eye Lots of shadows, short, sharp brows, and pointed corners make this eye more serious.

Angry eye Though this eye is really quite large, a very low, pointed brow makes it look angry.

Frustrated eye The brow is down and across the eye to show frustration. Don't forget some exaggerated tears of angry frustration!

Mysterious eye Lots of deep, rich colors and plenty of highlights make this eye really mysterious.

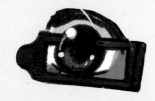

Bespectacled eye Use highlights to show the edge of the lens, and show the eye through the frame so that you don't lose the expression.

Closed eye Sleeping eyes arch downward, whereas yawning or laughing eyes arch upward. Expand on the expression with the brows.

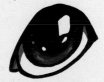

Animal eye Animals have different eyes than humans, so remember to check out photos for reference before you start drawing them.

Beady eye Simple, round eyes are perfect for animals or very cute characters.

The role of an artist is to communicate ideas without using text, so you need to know how to give your characters life and motion by drawing them in a dynamic way. Chibis make good practice subjects for expressing body language because their simple and stylized bodies can really be stretched and bent to create dramatic and dynamic poses.

Action lines

The key to getting the movement in your drawing right is to use an action line when you're sketching out your initial pose.

Drive

If you have a really dynamic shot, such as a sporting or fighting pose, it may be difficult to know where the action line goes: it might look like it should follow the arms, or one leg rather than the other. As a rule, it should generally follow the spine, as in this image: the other limbs are secondary movements that enhance the pose rather than affecting it.

Energy

Dynamic poses tilt around the center of gravity, which gives the impression of a snapshot of something in mid-movement. There are exceptions to the rule, but you'll generally find that poses that curve outward convey happiness and energy, whereas poses curved inward tend to look slouched or sad.

Action everywhere

Action lines apply to all characters, including animals, and sometimes even backgrounds and objects. Look at references of what you're drawing first, decide how they should move, and then draw from there.

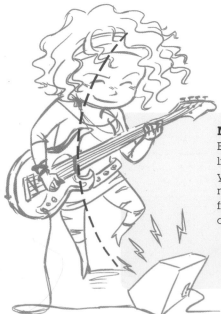

Movement

By keeping the action line smooth and curved, you'll immediately have more movement in your figure than if you simply draw it standing straight.

Body language

Once you understand action lines, you can use them to really exaggerate a character's personality. Whether a chibi is very energetic, quite introverted, or perhaps even aggressive, you can exaggerate its personality by understanding the expressive shapes that a figure can make.

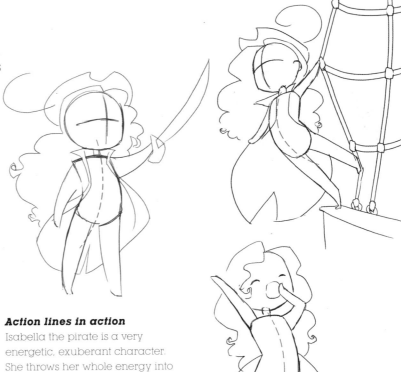

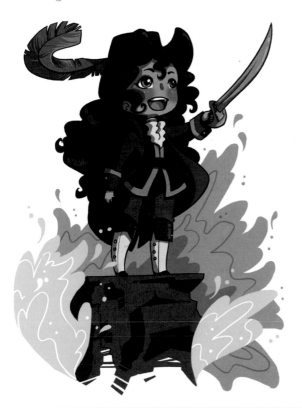

Action lines in action

Isabella the pirate is a very energetic, exuberant character. She throws her whole energy into everything she does, so her action lines almost always curve outward—it's a very open gesture, but she's confident and this shows. Even when tired or yawning, she never slouches or curls up.

Interaction between characters

When drawing two or more chibis interacting with each other, make sure to use your initial sketch stage to get everything right first. Check that the heads are all the same size, and that the characters connect with each other correctly before you add in any further detail.

Interacting actions

In this scene, the action lines help show exactly what's going on. The dog is pulling at the lead, excited to chase the butterfly, and as a result the little girl, who's holding onto the dog's lead, is running after it. However, her father, who is more practical, is trying to slow the two of them down by pulling back on the girl's hand. The action lines show the way that each character is moving and will help you to get your sketches right.

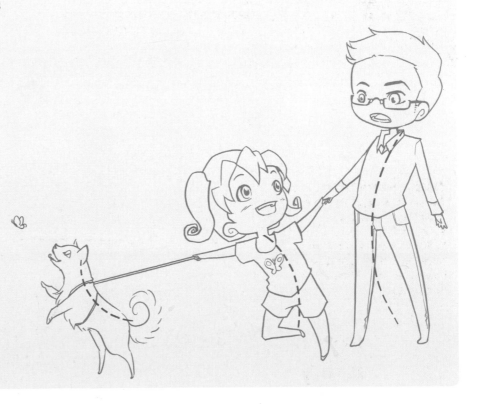

One of the integral parts of creating comics and finished artwork is the ability to ink your sketches well. It helps to have a steady hand and some confidence in yourself, because you may be inking straight onto your sketch. Alternatively, if you want to practice without making mistakes on your sketch, you can use a light box or tracing paper to make copies of your work before you begin. Because you're essentially tracing over lines that you've already made, the process of inking can be really therapeutic and enjoyable.

Inking styles

Inking is a great way to add style and depth to your sketches, which can be especially useful if you're drawing a black-and-white comic because the images have to stand out without extra color.

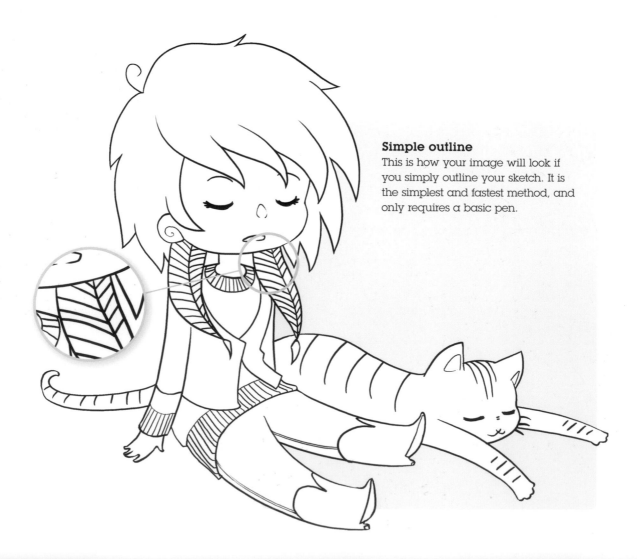

Simple outline
This is how your image will look if you simply outline your sketch. It is the simplest and fastest method, and only requires a basic pen.

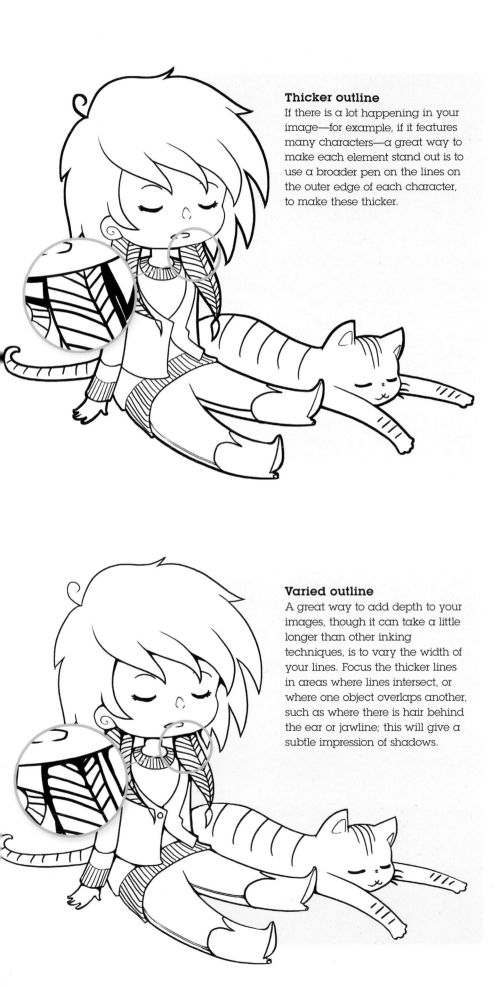

Thicker outline

If there is a lot happening in your image—for example, if it features many characters—a great way to make each element stand out is to use a broader pen on the lines on the outer edge of each character, to make these thicker.

Varied outline

A great way to add depth to your images, though it can take a little longer than other inking techniques, is to vary the width of your lines. Focus the thicker lines in areas where lines intersect, or where one object overlaps another, such as where there is hair behind the ear or jawline; this will give a subtle impression of shadows.

Inking media

Gel pens/ballpoint pens

These pens are cheap and easy to come by, and great for doodling or sketching roughly. However, they're not recommended for serious inking because they have a tendency to blob or smear ink, and it's difficult to vary the width of your lines cleanly.

Fine liners

Fine liners are designed for artists and technical illustrators, and so are ideal for inking your work. They are available in a range of types and brands—some are even alcohol-based, which means that they won't bleed when you color over them with markers. You can buy them in a variety of thicknesses, too, from 0.03 mm to thick brushes and calligraphy nibs.

Nib pens

Nib pens come with interchangeable metal nibs that are dipped in a pot of ink. Once you've bought the body of a nib pen, you can buy a huge range of nibs to go with it. Almost all Japanese manga is inked this way, so the effect is very authentic. However, the nibs can be difficult to clean and can sometimes drip ink, so you'll have to practice a lot with them.

Digital inking

Working on the computer is great because it lets you erase your lines if you make mistakes, and you can zoom in to get a better look at what you're doing. However, it can require a lot of software and hardware to get you started. An ideal suggestion would be learning to ink traditionally, then trying out digital afterward.

Every artist needs to know about color theory. Colors are so filled with meanings and emotional responses that color schemes can make or break a picture. For example, many people associate red with the brave, bold warrior; purple and gold with royalty; and green and yellow with villains—so take advantage of that, and make your character designs really effective! Here are some tips on creative coloring to help you come up with the perfect palettes.

Combining colors

Whether you're working with traditional or digital media, it's important to understand how different hues blend with each other. A hue is a color in its purest form, without any white or black added to it. In the most basic color wheel, there are six colors: blue, yellow, and red are primary colors; purple, orange, and green are secondary colors. A primary color is one that cannot be created by using other hues, whereas secondary colors are ones that are created by mixing the primaries together. Tertiary colors are created by mixing a primary along with a secondary color. Once you know your way around the color wheel, you'll need to know how to combine colors in an appealing way.

Chibi choices

For the purpose of creating color palettes for characters, pure hues are often too bright to be appealing, so you can make them lighter or darker to create either pastel or dusky palettes. Pastel colors are generally quite popular for chibi characters because they make an image look softer and cuter.

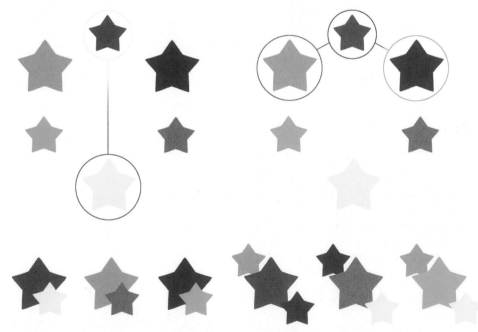

Complementary colors

Complementary colors are those that sit opposite each other on the color wheel. They have the greatest contrast against each other, and are perfect for adding small splashes of colored accents to an otherwise muted image. Understanding complementary colors can be really useful. For example, if you have a character that is too blue, adding a small pop of orange will immediately balance the whole image better.

Analogous colors

Analogous colors are three colors that sit next to each other on the color wheel—for example, blue, purple, and red. They aren't just useful for choosing a color palette, they can also help add depth to your shading and highlights. For example, instead of shading an object with a darker tone of the same color, you could instead color a purple object with red shadows and a blue highlight.

Breaking down color palettes

If you take the colors from the samurai character and lay them out on a grid, you'll notice that, though each hue is on a different part of the color wheel, they look very similar when they share the same tonal values. This is why, if you don't vary the tonal values, you may end up with an image that looks washed out and dull. Use shades from both ends of the scale, using contrasting light and dark colors to add interest. However, try to avoid using too many darker shades; otherwise, your image may end up looking quite heavy and muddy.

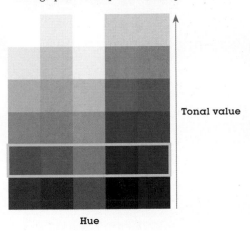

Shading and highlighting with colors

A great way to add depth to your images is to use your newfound knowledge of analogous colors in your shading. If you're drawing an object that's orange, for example, work toward a red tone for your shading and a yellow tone for your highlights; the same would work for a red object, where you would work toward purple shading and orange highlights. A general rule is to use warmer colors for shading, and cooler for highlights, though you can experiment and really try out what works for you. Have a look at the image and compare it to the color palette for the samurai; you can see immediately how much more vibrant the shades are. The most important thing to remember is to avoid using browns and blacks to shade because these will make your colors bland.

Tonal contrasts

The term "tone" refers to the lightness or darkness of a color. The tone of a hue can make quite a difference. For example, red can vary from a light baby pink right down to a rusty brown, depending on its tone. This is important to know because colors are associated with different emotions. Light, pastel colors are seen as very soft and gentle, whereas darker colors can seem more sinister or serious. Bright, pure hues are upbeat and energetic, but should be used in small quantities to prevent overpowering an image.

Depending on how you're coloring, there are different ways to handle tones. If you're using traditional media, it's generally wise to start with the lightest shades and work your way darker, because it's easier to fix mistakes this way. If you're coloring digitally, the best way to work is to begin with midtones and add shadows and highlights separately.

However, you can get some really interesting effects by starting with the darkest tones and working toward the lightest: try drawing with chalk or a white pencil on gray paper, or, if you're drawing digitally, use the eraser tool on a dark canvas.

Drawing in gray is an invaluable exercise in using tone, as a sense of good shading translates well to color work as well.

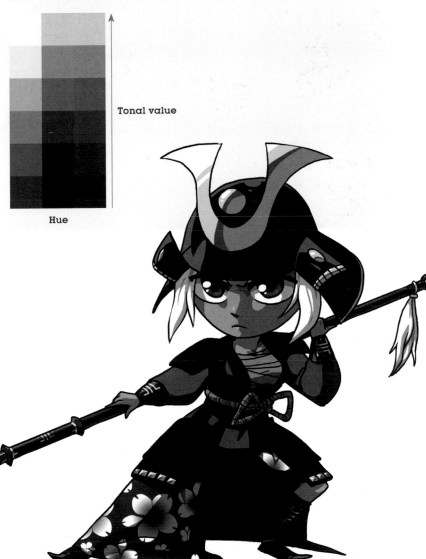

Working with contrast

To check the shading balance in your images, try stepping back to view them, or squinting your eyes to clearly see areas of light and dark contrast. If you roughly plan out your areas of contrast before you begin, you'll find working a lot easier.

Coloring with traditional media

If you're not completely confident when you start coloring, try layering colors very lightly until you've got the colors you want. Traditional media is great for this sort of thing; generally, you'll be building up layers of different colors anyway, so practice and see what sort of colors you can create by layering them up.

Coloring with pencils

Your coloring workspace

Whether working on a computer or on paper, your coloring workspace is important. Make sure you've got plenty of space around you because you don't want to knock things over or lose track of your materials if you're working with media that dries quickly, such as paints or markers. Make sure as well that you're working in a well-lit area. The ideal is to work during daytime hours because sunlight is relatively colorless and won't change the way that you see colors. If you're drawing in a room with yellow lighting, you may find afterward that your colors aren't what you thought they were; the same applies to the color settings on your computer monitor, so make sure you've calibrated these before starting out.

1 Colored pencils are fairly soft, so rather than lining your images in black ink, use a dark brown pencil. Make sure that it's nice and sharp to keep your lines crisp.

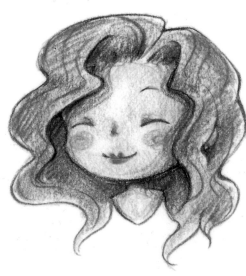

2 Because colored pencils can be layered up for different shades, start with a light tone and block in areas of color. Make sure to color lightly, and with soft strokes, to stop the shades from looking streaky.

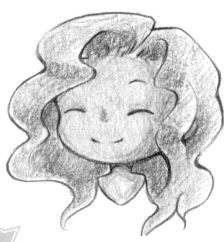

3 Using a slightly darker color, start to block in areas of shading. Be careful not to press too hard, because pencils can build up quickly and make it difficult to add further colors on top.

4 With a third, darker shade, add in a final layer of shading, making sure to blend all of your colors smoothly. Go over the outline again if it's starting to look a little faded.

5 Now that the base colors and shading are in, add in your final details, such as a blush, lip color, and lines to define the hair direction. You can also go over areas of color with another color, in this case an orange over the hair, to make it more vibrant.

Coloring with watercolor paints

1 Clean up your sketch using a waterproof ink. Lining pens intended for use with markers are ideal for this: you can test your pen beforehand by drawing a few lines and rubbing drops of water over them. Alternatively, you can paint your image and then add your outline afterward in a lighter-colored pencil.

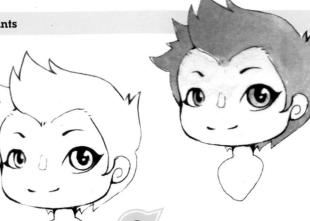

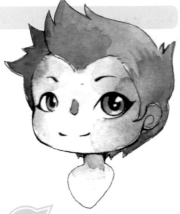

2 You can make plenty of colors, even from a basic set of paints. For example, yellow and red when applied lightly make a good skin tone; apply your paint in a wet wash in one try to ensure the colors don't end up patchy.

3 Create shadows by darkening your skin tone with slightly richer shades. Do not use too much water otherwise, your paper may warp. Keep a piece of paper towel on hand to dab up any excess.

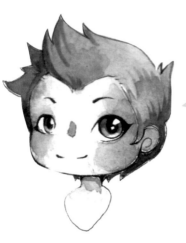

4 Add a final layer of shadows. At this point, you can start to describe more definite shapes, such as the harsher shadows in the hair. Make sure you don't paint over highlights in the eyes or hair.

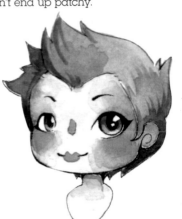

5 Once your image is dry, add in any final details such as blushes on the cheeks, lip color, and final hair details. You can use this opportunity to add in any extra highlights with a white gel pen or white ink.

Coloring with markers

1 Markers can bleed, so start with special paper designed for marker pens. Draw your image and outline it with a specialist pen for markers because most inks will bleed when you put alcohol-based inks over them.

2 Markers can dry quite quickly, so work quickly to avoid streakiness. Cover areas with flat colors; if you want to give the impression of a light color, such as on pale skin, leave areas white and just add colors in the shaded areas.

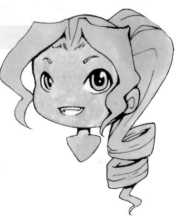

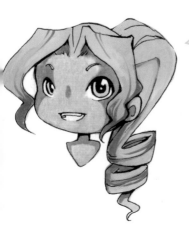

3 Use either the same marker, or a darker shade, to go back over and add areas of shadow. If you buy your markers in a set, they may come with a blender pen—a clear pen that will help your colors blend better.

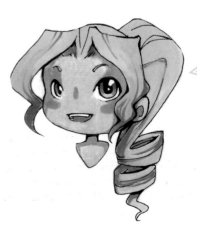

4 Add in a further layer of shadows and darker colors. If you have any highlights to make, such as in the eyes or on the hair, use a white gel pen or white ink. Be careful not to layer too many colors over each other because they can turn patchy.

Clothing is one of the final touches to put to your chibi drawings, and a well-designed costume can give just as much personality to a character as its expression or pose. Because chibis are so small, there may not always be a lot of room for detailed outfits, but you can make them stand out in a crowd with bold colors, cute patterns, or stylish accessories.

Fabric folds

The simplified figures of chibis make them ideal models for practicing drawing fabric folds.

On the figure

Because fabric folds around, or falls from, the figure wearing it, it will help to draw a basic figure sketch first. Visualize it as a three-dimensional object, and remember that the fabric will crease according to what it's draped over. Avoid drawing lines that cross over each other, or drawing folds in random locations.

Grid and line

If you're having difficulty, try drawing a grid over the fabric to help you visualize the shape of it. Another good way to show which part of the fabric folds over which is by using some of the varied line thickness techniques that you'll have picked up from inking techniques.

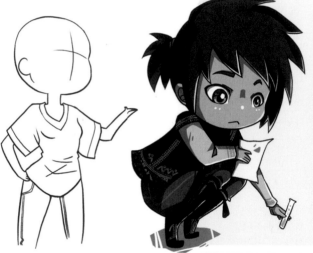

Fabric folds

In this pose, you can see examples of the most common areas where fabric may crease. Keep in mind that different fabrics react differently— for example, a thick suit fabric, or leather or denim, will barely crease, whereas chiffon or silk will create lots of small folds and creases where it hangs.

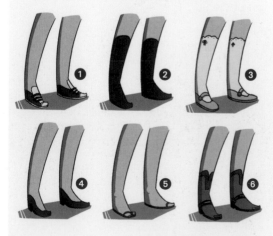

Shoes

Shoes can be difficult to draw, because some of them have heels and others have different-shaped soles. However, if you use reference photos or look at your own shoes, you'll get the hang of it with plenty of practice.

1 Sneakers 4 Heels
2 Boots 5 Sandals
3 Mary-Janes 6 Cowboy boots

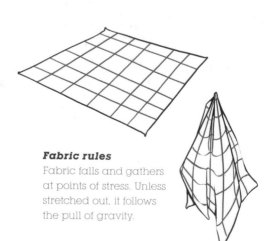

Fabric rules

Fabric falls and gathers at points of stress. Unless stretched out, it follows the pull of gravity.

Patterns

Using patterns is a great way to give outfits a little extra detail. You can find free textures online, or you can scan your own from wrapping paper, craft papers, or fabrics, and import them into your drawing software. Try matching up textures to your figures. For example, use origami papers for kimonos, or photos of Indian fabrics for saris. You can even draw your own textures and repeat them to make your own patterns.

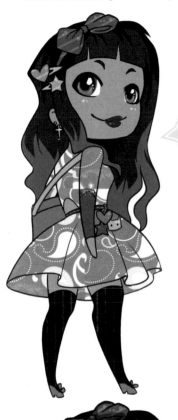

1 In your chosen drawing software, paste your chosen pattern onto a layer beneath your line art layer. Using the wand tool, select the areas where you don't want the pattern to show and erase them; alternatively, use the eraser tool and erase it manually.

2 Create a new layer above your pattern, but still beneath your line art, then draw in your shading using the brush tool. Set the layer filter to multiply so that the pattern shows underneath it. If it looks too dark, change the opacity of the layer or the color of the shading until you're happy with the final look.

FABRIC TYPES AND STYLES

The way you draw clothes depends completely on the fabric they are made from. The weight and type of fabric changes the way that an item falls, folds, and looks, so it helps to study fabrics before you begin.

Pleats Pleats are short, stiff creases that are generally sewn all the way up to the waistband, which is relatively broad and flat. Draw pleats as slightly curved rectangles that flare outward.

Chiffon/silk Chiffon and silk are both very light fabrics, so they fall in loose, soft ruffles. Draw a wavy hem with a loose hand, then extend the folds upward.

Ruffles Draw a wiggly line around where you want the hem to be and extend the edges of the folds upward to make it look ruffled. Don't forget to draw in the underside of the fabric where it shows.

Lace Lace comes in many styles. You can either draw the outline and fill in lots of shaped holes, or make up the shapes with a thick pen. If you're drawing digitally, you can copy and paste a section of an intricate design.

Fleece Fleece is very soft and fluffy, so avoid drawing it with straight lines and instead give it a slightly wavy edge. Because it's such a matte fabric, you don't need to add any highlights to it.

Denim Denim is a very stiff fabric, so you'll only need to put folds in around the crotch and knee areas. Draw two thin lines on the inside and outside of the sleeves and legs, to imitate the flat-felled seam that's with denim.

Fur Fur is very dense and soft, so draw it in broad, tufty spikes. Make it look varied by mixing large and small tufts of fur: you can make it look even thicker by adding in some thick shading.

Armor/metal Metal in armor is generally quite thick, so draw in broad edges. Give it big, chunky nicks and dents to make it look used. The amount of highlights you use will depend on how old or worn you want it to look.

Leather Leather is a very stiff material, so it doesn't crease much. However, it's distinctive because it gets lighter with wear, so add in lighter areas around the edges and where it has been creased.

CHIBI ANIMALS AND OBJECTS

Just like human characters, animals can be stylized into chibis by softening shapes and simplifying expressions. Because a lot of animals have one or two defining features that make them recognizable, such as the shape of their tails, their coloring, or the markings on their faces, they can be stylized quite drastically and still remain recognizable.

Evolution of cute

Your animal chibis don't even have to be complex to be recognizable. Even bulky or sleek animals can be simplified down to basic circles and other shapes, so long as their colors and markings are still distinctive. Sometimes even just drawing the head is enough to express the character, so long as you give it more human expressions!

Here you can see how to simplify your characters: the way that you choose to do it will depend on the context of your characters, your chosen animal, and your own personal style.

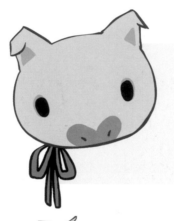

Simple face

A lot of Japanese art, especially chibi-style work, is very minimalist, so the easiest way to draw your character is to simplify it down to just its head. All of the emotion is drawn in the face. Think of text emoticons and the way that they simplify emotions.

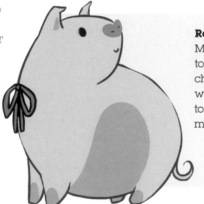

Realistic animal

Most animals are made of very simple shapes to begin with, so they're not too difficult to chibify. Remember to exaggerate their poses with lines of action and to use visual grammar to make their expressions more human.

Humanlike

Referring back to head and body proportions, try drawing your animal character on its two back legs with a 1:1 head-to-body ratio. This will make it easier to pose and also make it seem more human, which is perfect for animal sidekicks or mascots.

Anthropomorphic

Adding an animal head onto an otherwise human body will give your character its most flexible range of movement and emotion. There's also enough detail in this form to give your character more complex outfits, props, and accessories. Don't forget to still add in animal extras, such as markings, tails, wings, and ears.

SIMPLE FACES

You'll be surprised by how you can create a whole range of different animals just by picking out key features, such as markings, ears, eye sizes and shapes, and colors. By simplifying things, you'll also be learning how to pick out the most important visual details, which is a key skill for drawing chibis.

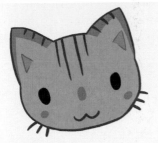

Cat
Cats are popular the world over. In manga, they are often given a wavy-shaped mouth, to depict their distinctive smiles.

Mouse
Mice and most other rodents have ears that are quite large and round, but folded on one side. Try changing the colors and markings for a hamster, rat, or gerbil.

Dog
A lot of dogs have quite large, floppy ears and dark noses. Different breeds are distinctive not just by body shape, but also through their markings. This one is a border collie.

Fox
Foxes almost look like a cross between a cat and a dog, with their slightly rounded ears and delicate faces: look at photos of them to get their markings right.

Rabbit
The most distinctive part of a rabbit is its ears. Whether they're upright or floppy, make sure they are really big and soft-looking.

Pig
Pigs may not be the first thing to come to mind when thinking of cute animals, but make their noses into a heart shape and give them floppy ears and they're already halfway there.

Bear
Bears have very round ears and noses. Try making the muzzle a different color so it stands out. Be careful when coloring dark-furred animals not to lose any line art details.

Owl
Already quite round and cute, birds are perfect for the chibi style. Change colors and markings, and you can draw practically any species.

Animal bodies

A lot of animals share similar body shapes, so by changing key elements you can draw different species with one simple body shape.

Round bodies
In contrast to longer bodies, round body shapes suit smaller, more compact animals such as hedgehogs, guinea pigs, and fish, and are especially suited to birds. Rather than drawing a perfect sphere, try drawing the shape freehand and flattening the bottom of the circle to make the figure look more natural.

Upright bodies
An upright, sitting body pose is perfect for rodents, such as squirrels or rats, mustelids like otters and ferrets, and other slender mammals, such as cats or raccoons.

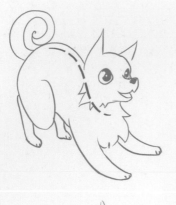

Playful

When dogs want to play, they'll drop down onto their forelegs, with their tails still in the air. Because dogs are very outgoing creatures, their body language is very open and enthusiastic.

Happy

When your character's having fun or enjoying itself, use curved action lines to help get an idea of movement.

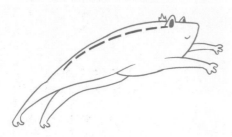

Jumping

When jumping or moving very quickly, a character's body will be stretched out and elongated. Use a slightly curved action line to stop the pose from looking too stiff.

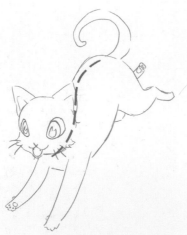

Chasing objects

Like dogs, cats like to play—keep their legs extended as they jump and chase after their toys. In this image, the cat is already landing on the ground, so show a curve in its spine to show the distribution of weight.

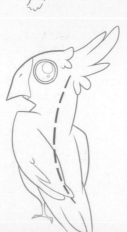

Sitting up straight

If you've ever watched birds, especially exotic types like cockatiels, you'll know that they've got a very distinctive way of moving. Getting the way that they sit—very straight and stiff—right will make your drawings immediately accurate.

Animal body language

The final key to really putting some life into your animal characters is to get the body language right. Animals move and react differently than humans, so you might find that you need to put some practice into posing them. Look at photos and videos of them moving, and keep in mind using the line of action to add movement to your drawings.

Ears

Many animals use their ears to show how they're feeling. For example, if an animal is interested or curious, its ears will tilt forward to face the object it's inspecting. If it's scared or angry, its ears will be back and flat against its skull; if relaxing, an animal's ears will often be straight up.

Tails

Tails can really show an animal's emotions. They are a little more complex than ears, however, because different animals use them differently. For example, a dog may wag its tail when excited, but for a cat this means it is frustrated. However, a tail sticking straight up is generally a sign of excitement across most animals, and tucked low and in between the legs is a sign of fear or submission.

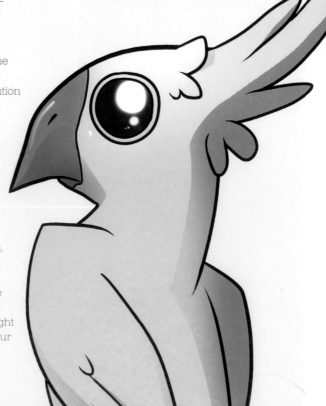

CHIBI OBJECTS

Anthropomorphic characters are extremely common and popular in Japanese culture. Inanimate objects and food with facial features and expressions are made cuter and more appealing because, with these characteristics, it is easier to associate with them on a personal level. To keep them in the chibi style, all you need do is simplify them down in the same way that you would simplify a human or animal character, and apply the same visual expressions.

Simple and cute

The same rule for simplifying your human figures applies to drawing chibi objects. Whereas real-life objects have lots of straight lines and sharp corners, make sure to curve your lines slightly and round off any unnecessary points. Start with round, chunky shapes and build your images from there.

Remove extraneous details, such as crease lines, marks, and texture, and if you want to keep these in, then enlarge and make a feature of them. Color with plenty of soft, pastel colors and, if in doubt, a cute expression adds an extra *kawaii* (cute) factor! The images here are an example of how objects can be transformed.

Spoon
Shorten overly long sections, such as the handle on this spoon. As with human characters, exaggerate the "head" area to give your objects a cuter ratio.

Heart
Make objects look rounder by exaggerating curves and shortening elongated areas.

Sketchbook
Many details, such as the ring binding, can be simplified down to a matter of lines.

Star
If you have a very spiky object, add a slight curve to straight lines and even out the geometrical shapes.

Paint tube
By using visual grammar (see page 20) and expressions, you can give your objects cute personalities and add a little bit of humor to your drawings.

Cake
Remove extraneous details, such as crumbs and icing piles. Focus on round areas, such as the cherry and the wavy frosting.

Mug
Simplify areas with lots of lines, such as the rim and handle. Remember to add in a cute face!

The process of drawing is rewarding in itself, but you may find that you want to display your art and get other people's feedback on it. You may realize that you want your drawing to be more than just a hobby and that you might even be ready to take it on as a career.

Presenting your work

The Internet makes it easy and convenient to promote your artwork, and build contacts, and you can also put together a physical portfolio to take with you to manga-related events, where professionals sometimes do portfolio reviews for aspiring artists. Here are some guidelines to help you make the most out of displaying your art.

Platforms for promotion

Online galleries
There are numerous galleries online that are free to use and aimed at helping beginner artists create a portfolio of work. Many of them have social features, such as forums, communities, and interest-specific

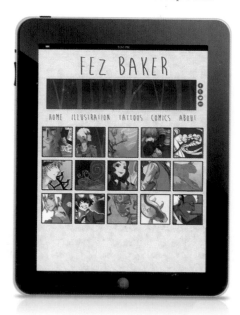

groups, so they're great for meeting and interacting with other artists.
Pros: These web sites are good for a first portfolio, as there's generally no knowledge of coding or programming required. There are lots of beginner artists already using them, so you can meet similarly minded people.
Cons: It's quite difficult to really customize these web sites, so you may find that you're stuck with a layout that doesn't fully represent you. Also, if you want to start a career in art, many clients will look less favorably on a free gallery portfolio.

Online forums
Forums are a great online media for networking and interacting with other artists. You can pick up tips from and chat with professional artists, and gather feedback on your work.
Pros: You'll find lots of helpful tips and inspiration on forums to help you improve your work. Professional artists also frequent these message boards, so you'll be able to find information from them, too.
Cons: Forums aren't generally designed for displaying artwork, so they're less a place to use as a portfolio and more a place to find information on art techniques. However, they're still great for receiving feedback on any new artwork.

Online presence
Your online portfolio should contain information about you and, most importantly, a collection of your drawings.

Art blogs
Many artists keep an art blog, or sketch blog, as a quick and easy way to keep people up-to-date with what they're drawing. Because they're great for posting works in progress, they can be kept in addition to an online portfolio. There are also lots of free blogging platforms out there, so you won't have to pay.
Pros: Free to use and usually fully customizable, so you can really personalize it to your own style. You can also follow and promote other artists, so they're great for networking and letting other people share your work. They also feel less strict than a professional portfolio, so you can post up loose sketches and show your working process.
Cons: A lot of blogs are designed to show posts in a chronological order, so they're less practical as a professional portfolio and more useful as a way to promote your very latest work and to network. They can also be difficult to get noticed if you choose to use a blogging platform that not many other people use.

Portfolio web site
Having a proper web site is the most professional and useful way to create your web presence. Clients will be more impressed by a personalized URL and smart, clean-looking design.
Pros: A personal web site shows professionalism and is easily found by clients or publishers. The visual look of your web site is also fully customizable and can be used to really express

you, the style of your artwork, and the kind of work that you do.

Cons: Setting up a web site can be quite expensive. You'll need to pay for a custom domain name and the hosting space, which may need to be renewed annually, and though you can find web sites that offer free layouts, you may want to pay for a professional to design yours.

Printed portfolio

Even if you do most of your networking online, it still helps to have a printed portfolio. This is great for carrying to social events, such as comic conventions or artists' meetings, and looks smart and professional. It can also come in handy for interviews or higher education art courses.

Pros: Having a printed portfolio is a classic way of representing your work. It's also personally satisfying to see your work printed and mounted in front of you.

Cons: It can be cumbersome to carry if it's too big or heavy, and will need to be updated regularly to keep the work in it fresh. Printing and mounting costs for new portfolio pieces can become rather expensive.

Copyright and intellectual property

When you're first starting out, and even once you're more confident with your drawing, you may want to reference photographs for poses and ideas. However, as soon as you start to display your work in a public place, most people will presume that you are taking credit for every part of that image. One of the easiest mistakes to make when looking at other art online is to forget that it was drawn by someone else, and therefore belongs to them, so you should avoid copying other artworks and images wherever possible, unless they are promoted as specific aids (tutorials, outlines for coloring, or stock photographs) for artwork. Check the following notes to ensure you avoid any possible copyright infringements.

Tracing

You must never give a traced image out as your own. Traced images are very easy to spot, especially if the artist it has been traced from is well

known. Every artist has a distinctive, personal style, and you may end up with a portfolio of traced images with greatly-varied styles, which would look very strange.

Referencing

Referencing is when you have drawn an image by copying another, but have changed some details. You should avoid copying other people's artwork for two main reasons: it is frowned upon and the artist may have made anatomical mistakes that you copy without realizing it. Some web sites offer what is known as stock photography specifically for artist reference, which is ideal to learn from if you are unable to find a local life-drawing class. However, take care to always credit the photographers.

Fan art

Producing fan art is a great way to get yourself noticed online. Because a lot of people will love a certain TV show, movie, or game, they will be eager to share your artwork, which is a great way to find some free promotion. However, there are certain things that you need to be careful of.

Because fan art is copying an existing character and existing design, there's still a certain element of borrowing someone else's work. Avoid tracing or copying existing artwork, whether fan-made or official.

Never sell any fan art or fan merchandise, because the characters, ideas, and environments all belong to the studio that created them. Even if you created the artwork from scratch, you do not have the rights to sell any fan art, including prints, art books, buttons, T-shirts, and any other merchandise you make. Also try to avoid including fan art in a professional portfolio.

As a result, fan art is a great way to get your work seen by a larger audience, but may be dissatisfying in the long run because you will not be able to make any profit from this work. However, producing fan art is a great way to develop a fan base to whom you can start promoting your own original artwork.

PRINTING AND DISPLAYING YOUR WORK

Whether you display your artwork online or in print, it's important to know how to present your work well.

Resolution

When working digitally, the resolution of artwork is important. You should generally have two files for each piece of artwork, at two different resolutions. Standard web resolution is 72 dpi (dots per inch), and is ideal for uploading images online because the file will be small and fast to load. For printing or scanning artwork, you should generally work between 300 and 600 dpi. This will create a very large file, but it will be at a high quality that can be printed or displayed very large and crisply.

Common file formats and sizes

Though JPEG is the most commonly used file format for saving images, you have to be careful when setting the quality to save them at. Anything less than top quality will tend to make your images artifact, which is the term given to the small pixels that can blur a piece of work Alternatively, you can save your work as a TIF or PNG file, which will have a larger file size but be of higher quality.

Printing tips

If you are printing for a portfolio, the type of paper that you use is really important. Try to use a heavier weight paper, such as 90 or 140 lb (250 or 300 gsm), which shouldn't buckle if your portfolio is opened in a humid or warm area. Also, use a silk finish paper or special art paper to ensure your colors are rich and vibrant. Photo paper and printer cartridges, especially cartridges for high-quality printers, aren't always cheap, so it may be more practical for you to copy your images onto a CD or USB stick and take them to a local printing store.

Getting published

With enough hard work and determination, getting paid to do what you love is one of the most fulfilling experiences you can find. You may decide that you don't enjoy drawing professionally as much as you enjoy drawing for yourself, but have a look at the notes below to see if it could be the career for you.

Am I ready to try?

Most artists who decide to go professional have started out as hobbyists. While it can be exciting to start making art your full-time career, you should also understand that you may lose the time to draw for yourself, and that the way you approach your artwork may change.

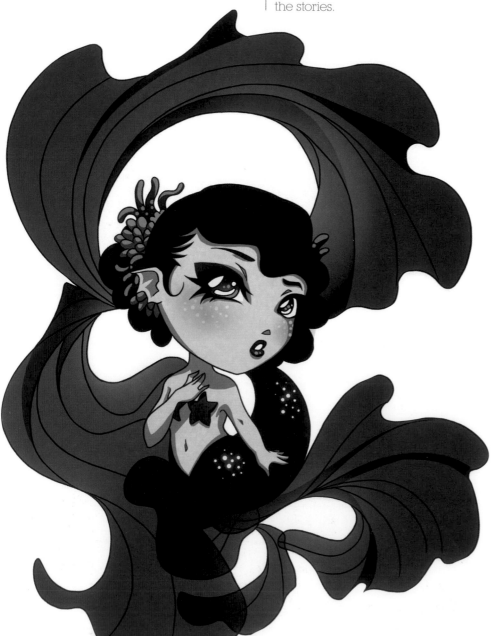

Am I good enough?

The most important thing to consider before trying to get published is whether you are ready for it yet. Be honest with yourself, and compare your work to existing industry standards—your friends and family will be less objective than a publisher or client.

Am I willing to draw other peoples' ideas?

Many people want to go into art as a profession to draw their own stories and characters. While this may happen, especially if you work hard at it, to bring in regular pay checks, you'll frequently have to draw comics and illustrations for other people, even if you're not particularly enthusiastic about their style or the stories.

Can I take criticism?

Because you'll be working for someone else rather than just yourself, you'll need to be open to feedback from clients and the public. You may receive criticism, or be asked to change something that you liked, but you shouldn't let it discourage you. You may also be turned down for a lot of jobs, not necessarily because you aren't good enough for the client, but because he or she is after a specific style that is different from yours.

Can I meet deadlines?

If you want to be a professional, you must be able to meet deadlines. If you work from home, you may be tempted to sleep in or take breaks whenever you want, but this will get you into more trouble than it's worth! Schedule all of your work down to the last page or sketch, and if you frequently get your work in early, your clients are more likely to remember you and hire you again.

Am I willing to network?

As a freelance artist, you are the one in charge of promoting yourself. Use web sites such as Twitter and Tumblr, and comic events, to make friends in the industry: you'll be more likely to hear about or be recommended for job opportunities. And if you promote the work of other artists or writers, then they will be more likely to promote your work.

Can I distinguish between personal and professional social networks?

You might use social networking sites to talk about personal matters, but this isn't the sort of thing that clients want to see. Complaining about work or other clients is only going to put potential employers off. If you really have to share it, make a separate account for your personal life that is made private. Use your professional networks to promote your artwork and publications and to make preofessional contacts.

Take it easy

Don't let yourself get discouraged if a client asks you to change an image that you like. It's not personal criticism, and it may happen a lot if you start drawing professionally.

Can I be professional all the time?

It's really important to make a good impression on your clients. Always sign off your e-mails professionally, use good grammar and spelling, and respond to e-mails and phone calls promptly. Don't make promises or offer deadlines that you can't follow through with, and try to avoid using emoticons or abbreviations when discussing work.

Am I organized with my paperwork?

Once you start receiving serious commissions, it's important to register as self-employed with the authorities and to remember to file your taxes on time every year. Learn to write and file invoices, and keep an organized folder for all of your payment slips and work-related receipts.

Am I ready to work unsociable hours?

Working as an artist isn't always a nine-to-five job. If you've got a deadline looming, you may find that you have to work late into the evening, or miss out on social events with your friends, or even work when you are uninspired or ill.

Can I take the initiative?

You may be an amazing artist, but you're not going to get hundreds of job offers just by being good! Especially when you start out, you're going to have to go out there and promote yourself. Contact publishers and magazines, as well as design and illustration agencies, and let them know what you can do. If a client is looking for an artist for a specific job, send through some visual ideas without expecting to be paid for it: it's the extra initiative that will make you stand out from the crowd.

Am I able to price my work fairly?

When you first start out, you may dread being asked how much you charge. The price that you give should depend on your experience, the size of the project, and the size of the client. If in doubt, it's fair to ask what the client's budget is and work around that; otherwise, calculate how long the project will take you and set an hourly rate. What may sound like a reasonable fee to you may actually work out at less than the minimum hourly wage.

Can I work two jobs at once if need be?

Drawing professionally is not a highly paid job, so it helps to be realistic about your living expenses. There may be gaps between contracts where you'll need a financial safety net, so consider having a second daytime job, taking on more than one contract at once, or having some savings in the bank. Some artists supplement their income by giving workshops or lessons.

Investing time

If you're thinking of going pro, make sure that you're organized about deadlines and paperwork first, because you may be spending a lot of time working late into the evenings or over the weekends.

Mounting tips

Most images, when printed, will come out with a slight white border around them. This can appear unprofessional, and it's best to trim this off before putting it into your portfolio: using a guillotine is recommended because scissors can make the edges look uneven and hand-finished. Mount your images onto a piece of black, white, or cream cardstock using mounting spray or double-sided sticky tape. Avoid using glue or adhesive tack because these can buckle the paper and cause marks that are visible from the front of your image.

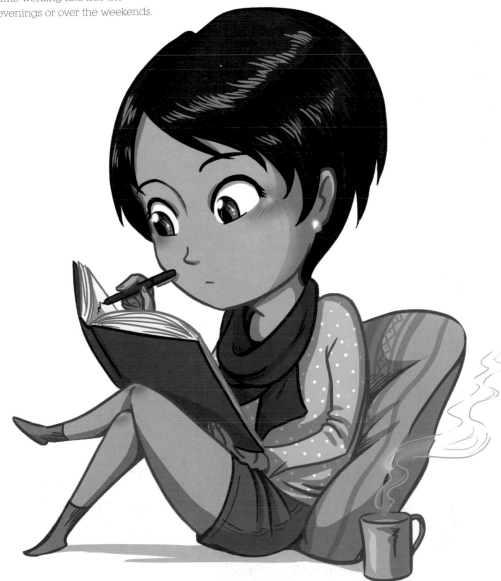

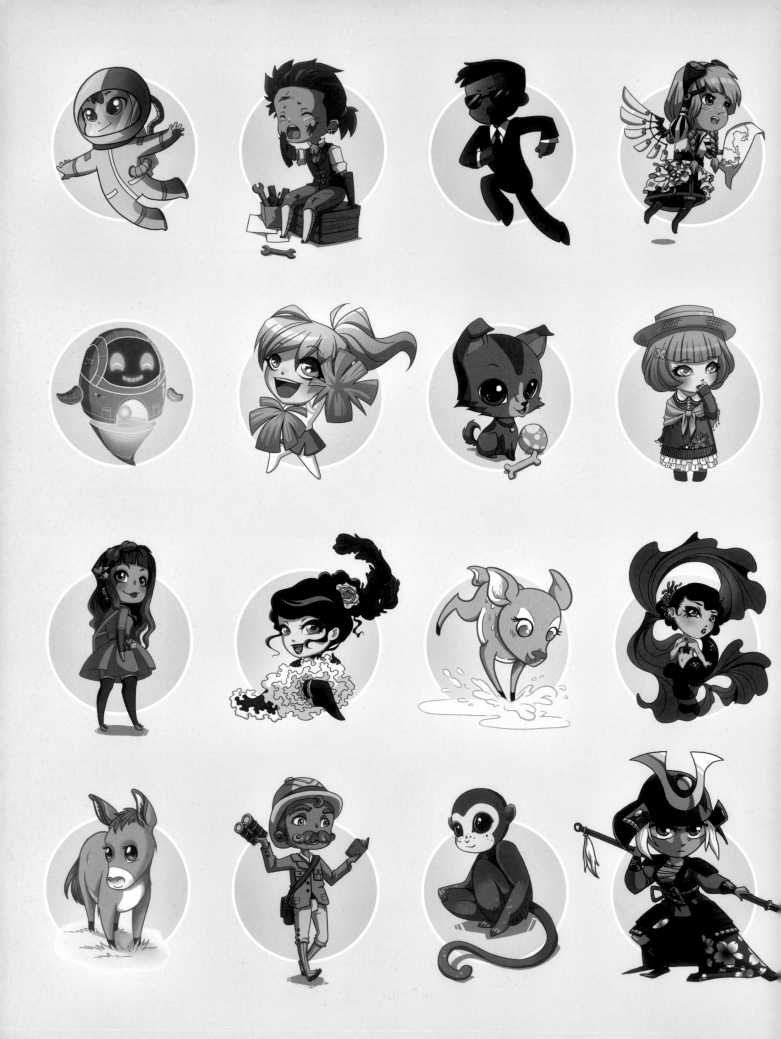

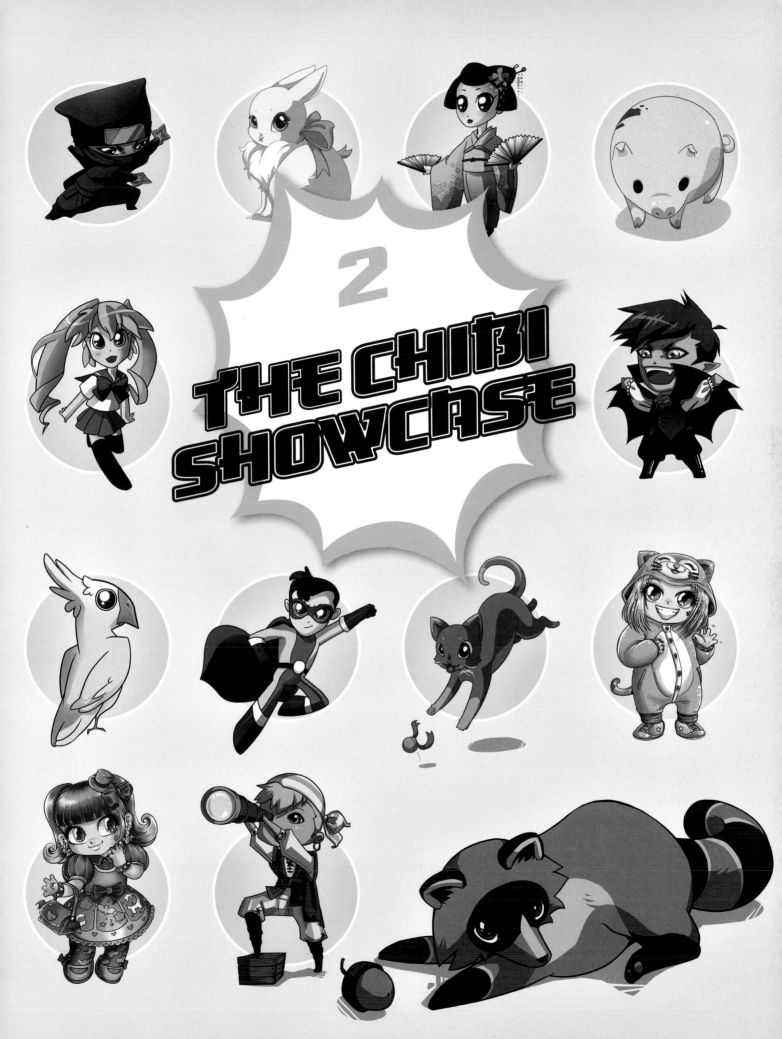

THE CHIBI SHOWCASE

2

Paint a masterpiece with **PUJA** the artist

Puja loves art. As she delves into the wonders of painting, she is never afraid to get messy. Puja is energetic, enthusiastic, and passionate about her art.

Style notes
To set off Puja's eccentric personality, she's shown in an active posture, proudly holding her paintbrush. Her distinctive, artistic wardrobe is complemented by bright colors, which keep the image busy and full of life.

Color Palette

With colored pencils, it is important to blend your shadows not with black or gray, but with other, richer colors, especially when your character is worked in such a bright palette. Keep Puja looking three-dimensional by using a variety of tones.

Skin Eyes

Hair

Clothes

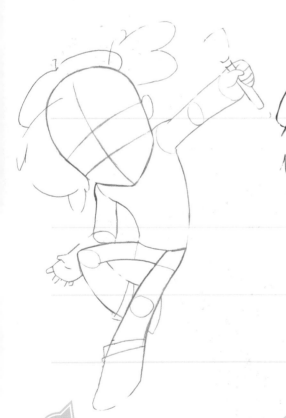

1 Take care to ensure you keep the body in chibi proportions using simple block shapes for the torso and cylinders for the arms and legs. Map out the face with contour lines.

2 Using a light box or tracing paper, trace over your shape skeleton with a thick black pencil and add in the extra detail with a thinner line. Making a difference in line weight will give your character more dimension.

3 Color in Puja and add gradients to her hair and knees to ensure she looks solid. Take care not to go over your line art; otherwise, you may end up with some smudging.

ADDING IN PROPS

Think about what sort of equipment your character could be surrounded with to help set the scene.

Puja has an abundance of art equipment for her work. You could add in drafts of her work, showing how she begins her artistic process. Including elements such as an easel (2) or palette and brushes (3) will give your character a sense of scale. Make sure you keep all items in proportion to each other and to Puja. You can rough out a figure as a reference for proportions (1).

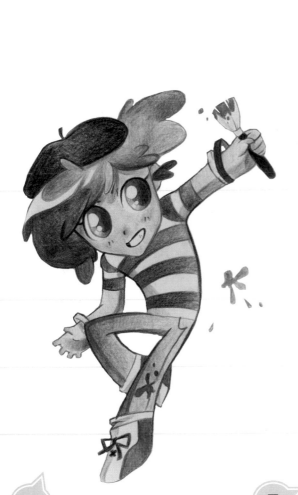

4 Make a thin, lighter line to mark out where shadows should be, and fill them in a consistent, even tone to add depth to your drawing.

5 Go over the line art again with a black pencil to emphasize the shadows, then add highlights to the hair, eyes, nose, and bangles with a white gel pen.

See also

Dressing your chibi
page 30
Chibi animals and objects
page 32

Compose with
CHRISTOPHER

Christopher works hard, but likes to keep it laid back. His favorite kind of gig is an acoustic set in a small café.

Color Palette

The warm colors of Christopher's hat, hair, and skin, and the cool colors of his clothes, could make him look a little unbalanced—warm at the top and cool at the bottom. A tiny dash of warm color added to his shoes helps balance the colors out.

Skin

Clothes

Hair

Keyboard

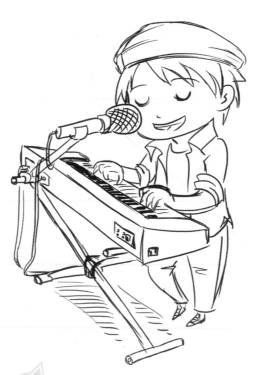

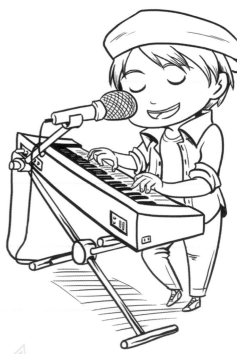

1 Start by making sure your proportions are right: Christopher is about three heads tall. Sketch in where the keyboard will rest on the ground, making sure it aligns with the figure, then ensure that the supports use the same perspective as the keyboard.

2 Develop the details. Chibi proportions mean that characters won't interact with items in the same way as realistic characters, so adjust the height, size, and details of various elements of the drawing to get the right feel. The oversized microphone helps for a cuter look.

3 Add line art. You don't have to use straight lines for objects with straight edges, so draw the keyboard freehand to add a bit of a curve to it, for a friendly, cute quality. Curved lines can also add shape, like the curved hatching on the microphone, which helps it look round.

EXPRESSING PERSONALITY
Use expressions to make your character really come to life.

A character's expression is often the focus of an image, and it communicates information about the image, situation, and the character. These rough sketches showcase a range of expressions that fit in with Christopher's musical career: talking to the crowd (1), singing an acoustic set (2), and wailing a ballad (3).

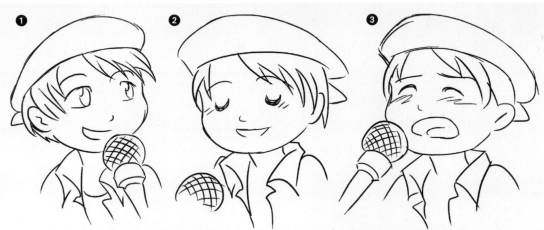

See also

Creative coloring page 26
Chibi animals and objects page 32

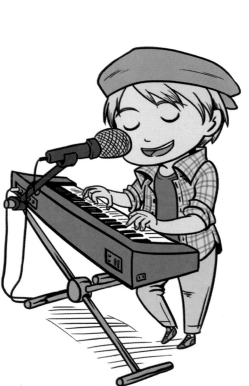

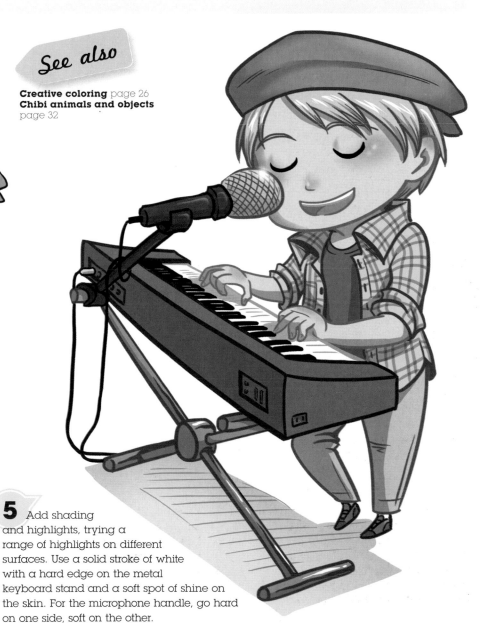

4 With a large object that would be black in real life, try using a gray to stop it overwhelming the image. You can even use a tinted gray, like the warm brown-gray on the body of the keyboard. Use different grays for the details and to add more variety.

5 Add shading and highlights, trying a range of highlights on different surfaces. Use a solid stroke of white with a hard edge on the metal keyboard stand and a soft spot of shine on the skin. For the microphone handle, go hard on one side, soft on the other.

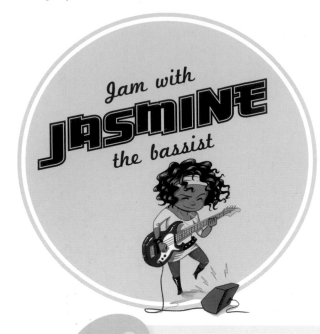

Jasmine likes recording well enough, but what she really loves is touring with her band. There's nothing like the energy of a crowd, and she always throws herself into it 100 percent!

Style notes

Jasmine is an energetic character, so keep her clothes fairly simple and streamlined to show movement easily. She has a punky, 80s-influenced style and plenty of room for accessories, but the overall look avoids too many details, which could make the image look cluttered.

Color Palette

Jasmine has a classic shiny red bass, which makes a great focal point. Keep the other colors softer and more muted to help that red pop out.

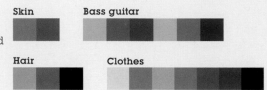

Skin Bass guitar

Hair Clothes

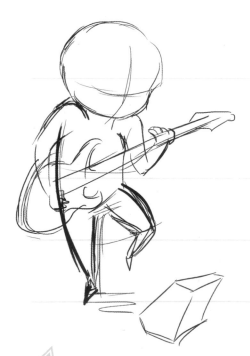
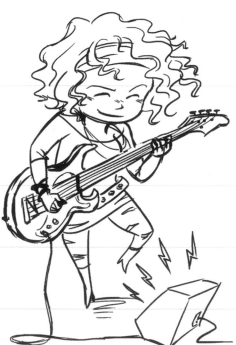
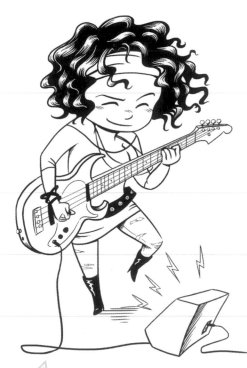

1 The main action line of the figure is a strong curve on the left. Use bold, simple lines to figure out the pose and give it energy. Then build up basic shapes and check your proportions. Rough in the objects in the scene to make sure that the figure is interacting with them in a natural manner.

2 Develop your sketch. The simple shapes of Jasmine's outfit show off her movement; add movement to her hair to make her look even more energetic! Take the time to look up reference images for her bass guitar.

3 It's time to ink your image. With dark hair you can add vibrancy and light by using highlights. Taper your lines into them so that the highlights seem to fade into the hair. Use different kinds of lines in the image to give it depth, such as the short, feathery lines around the holes in her jeans, which indicate frayed denim.

DEVELOPING COSTUMES

A character's oufit plays a huge part in formulating its personality.

When you're designing your character, do a few quick sketches before you start your image. Even if you are already sure she should be dressed in a costume for the stage (2) you can still play around with a casual look (1) or come up with a party outfit (3).

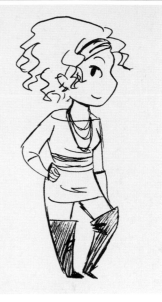

See also

Dynamic drawing page 22
Dressing your chibi page 30

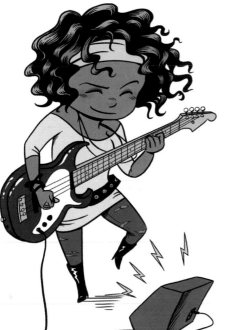

4 Start putting down your base colors. Most of the colors are solid, but adding a gradient to the hair helps to give depth and indicates the light source. Keep it simple, but add a few details, such as eyeliner and flushed cheeks, and some shine on the bass.

5 An orange-pink for the shading keeps the image warm and ties the color scheme in with that focal red bass. Try out different types of shading—in this case, solid where shadows are cast by the hair and bass, and softer where you want to show curves on the arm or face.

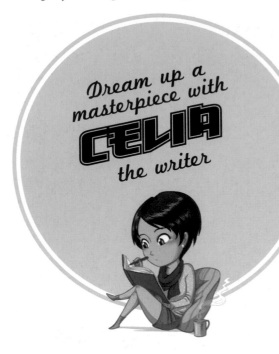

Celia knows that great writing comes only with hard work and lots of practice, but she also knows the importance of a cozy corner and a good cup of tea.

Style notes
Celia is curled up at home, so simple, cozy clothes are the order of the day. Bright colors and patterns help add plenty of personality.

Color Palette

This palette features quite a few different colors, but many of them are fairly subdued, so the image doesn't look busy. A couple of colors are very saturated—such as those for the scarf and mug—to add variety and balance.

Skin Clothes

Hair Objects

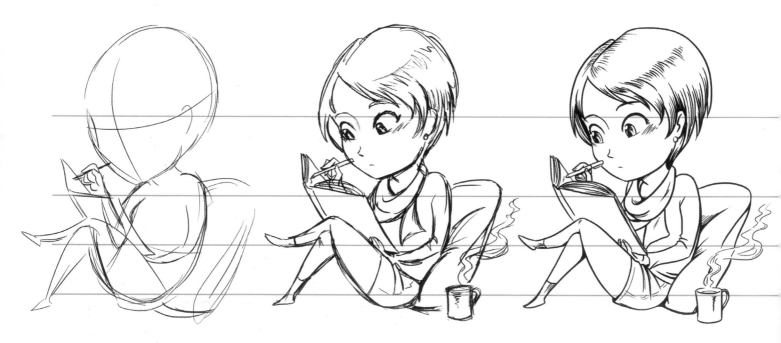

1 Start with basic shapes. Part of Celia's body is hidden by her legs; in cases like this, sketch in the hidden parts, too, to make sure that everything lines up.

2 Develop your sketch. Because Celia has a static pose, her expression will be the focal point, so spend some time on her countenance of thoughtful concentration. Extra details, like a steaming cup of tea, add to the image.

3 When adding in your line art, keep most of it clean and simple, but add some detail here and there—for example, in the hair. Some particularly smooth hair types reflect light in a halo shape, with a darker contrast underneath, which you can draw in.

EXPERIMENTING WITH POSES

Your character's pose can say a lot about her. Don't be afraid to try out a number of them first before you begin.

It's a great idea to sketch a few options before you start. Perhaps you want a pose that conveys a serious-but-relaxed feeling (2), a chilled work vibe (1), or a thoughtful concentration (3).

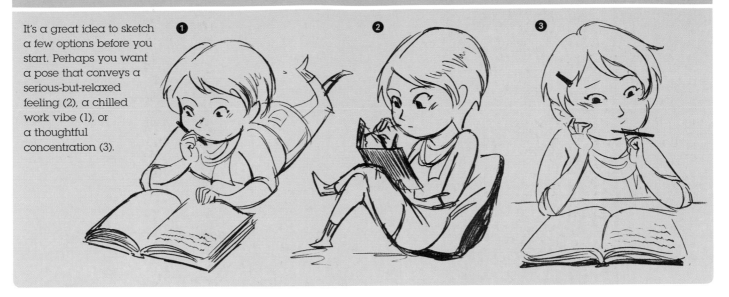

See also

Creative coloring page 26
Dressing your chibi page 30

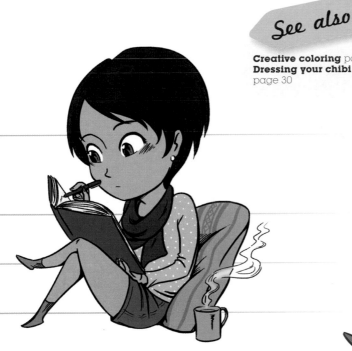

4 Use a combination of bright and more muted colors to create a balanced image. You don't have to add all the details in the line-art stage. Use flat colors here to add patterns to the cushion and Celia's shirt.

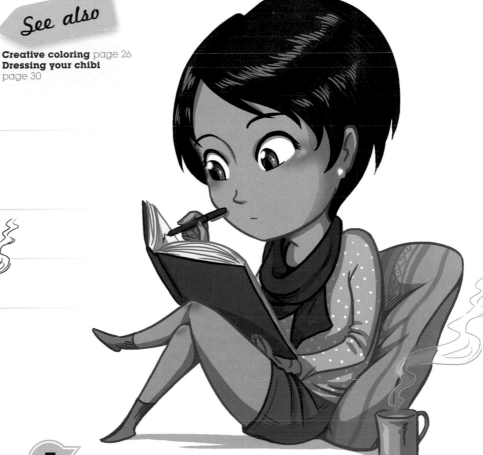

5 When you're using both colored line art and tinted shadows—like the pink-purple shadows here—do the shading before you choose the colors for your line art, to make sure that they don't clash with the shadows. Finally, add a few cute details, like reflections in Celia's eyes, or her rosy knees.

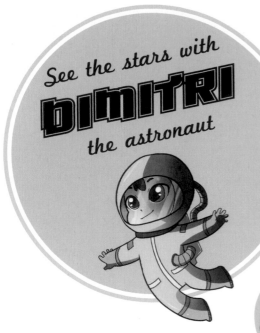

See the stars with **DIMITRI** the astronaut

Dimitri is a curious, funny, and enthusiastic guy. He combines his intelligence with his love of space to go on amazing adventures, discovering life in far-off galaxies.

Style notes
Make sure you have some references to work from for your space suit. There will be a variety of materials and textures for you to try to replicate.

Color Palette

The mainly cool recessive palette perfectly captures outerspace. The subtle, almost neutral blue-grays have a futuristic, metallic look.

Skin　Hair　Eyes

Space suit

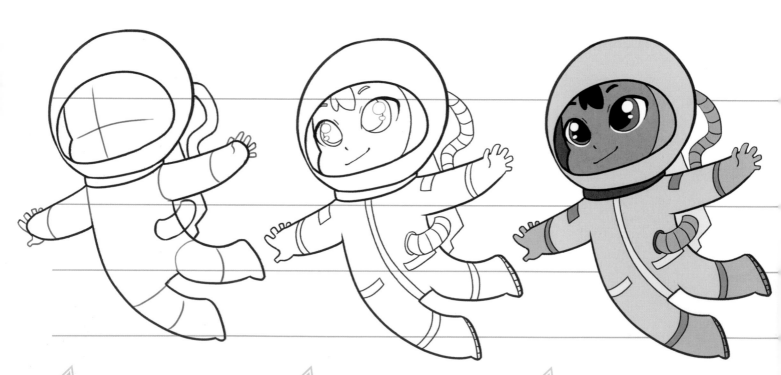

1 Make Dimitri's body proportions even and relaxed. Take note of the angle of his hands and feet: you want to make sure it looks like he has no gravity constricting his movements.

2 Clean up your lines with a thick brush setting and use a smaller one to fill in all the details. By using various line thicknesses your art will look visually more interesting.

3 Select your colors and fill in the linework. Don't worry about coloring in his visor yet; just focus on the basics.

DRAWING SPACESHIPS AND SCI·FI VEHICLES

Every astronaut needs his handy rocket. Simple shapes and forms will help you design and draw your own space vehicles.

Using the same steps to draw Dimitri, block out a rough shape for your rocket. A lot of rockets are shaped like a rectangle but with a rounded end (1). Add in some extra details, such as rocket wings, and go wild with the designs on the sides (2). Then color your rocket with bold colors, not forgetting to add highlights to its metallic surface (3).

See also

Digital media page 14
Dynamic drawing page 22

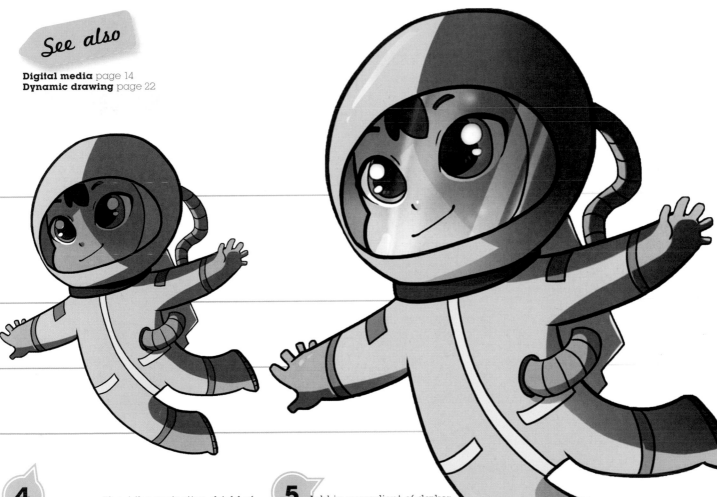

4 In space, without the protective shield of the Earth's atmosphere, the light of the sun would be much more intense. As a result, the shading should be a lot darker and stronger than on any normal, earthbound character. Mark out the light source and then fill in the shadows.

5 Add in a gradient of darker tones in the shadows and a gradient of lighter shades on the rest of the suit. To make the space suit look reflective, add gradient highlights in white so that it looks as though they're fading into the shadows.

Save the world with **JAMES** *the secret agent*

Determined to fight crime and get the job done quickly and quietly, agent James is a stern guy who appears tough, but also has a pretty cool personality.

Style notes
James likes to look smart in his formal black suit. His active pose and black sunglasses tell us that he's a fit and strong person with a great number of secrets to keep.

Color Palette
When using a lot of dark colors, make sure to start with a lighter tone, then use shading to darken the image to make sure that you don't lose any detail.

Skin

Hair

Clothes

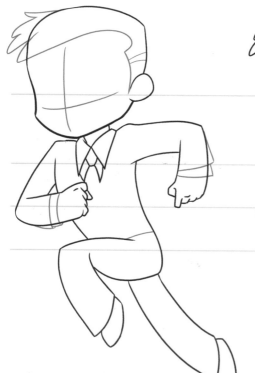

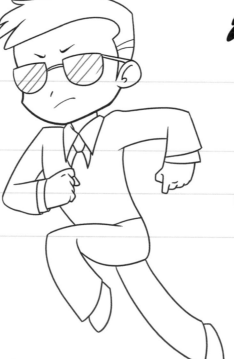

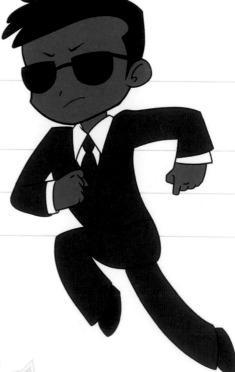

1 Rough out James's running pose with blocks and oval shapes. Make sure that all of his body parts are the same length, and map out where you want to include any details.

2 Draw over your sketch with clean, dark lines, ensuring they are of an even thickness and connected together. Add in any extra details, such as his glasses and expression.

3 Fill in all the shapes with the appropriate color. The key to clean art is to make sure there is no color bleed outside of the lines, and you can guarantee this by using nice thick lines around your character.

SECRET AGENT EYE WEAR
Props can help convey more information about a character.

Agent James knows how to look cool, especially with his collection of glasses: he has a pair for every occasion! Be it reading glasses for looking over those important government documents (1) or sunglasses for enjoying his many adventurous travels (2 and 3), he's always got the right look.

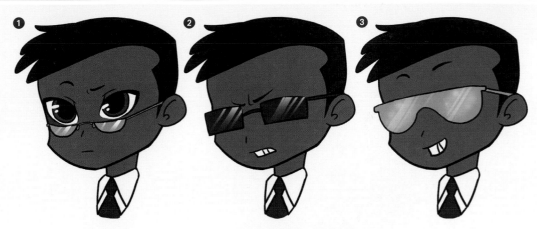

See also

Basic drawing techniques
page 16

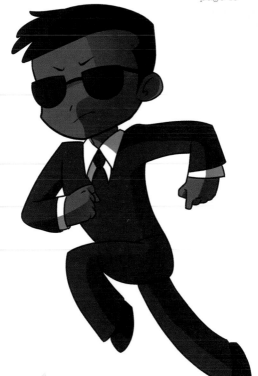

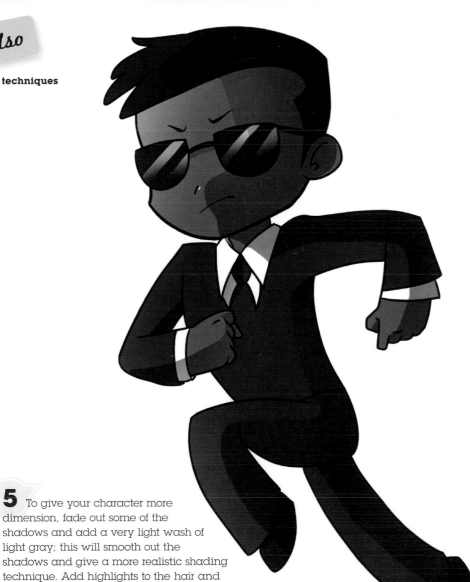

4 Identify the light source and add shade using tones that are darker than your first color. It is best to line the areas to be shaded and then fill them in to avoid making any mistakes.

5 To give your character more dimension, fade out some of the shadows and add a very light wash of light gray; this will smooth out the shadows and give a more realistic shading technique. Add highlights to the hair and glasses and use the soft-shaped eraser tool to lightly add a gradient to one end of the highlight.

Go retro glam with

ELLIE

the shopaholic

Ellie is always on trend with the latest fashions, and also knows just where to find the best vintage labels. She can sniff out a good bargain a mile away!

1 Use basic shapes and simple lines to sketch out your figure. Make your figures look fashionable by using sleek shapes and taper their arms and legs to delicate points. Ellie has very loose, curly hair, so use plenty of sweeping curves and curl it at the end. You can use thinner, more delicate lines to draw classy swirls and curves. Use a deep red to block in the shape of her lips.

Color Palette

Vintage fashion often features deep, rich colors, with a few select patches of brighter colors that pop out. Ellie wears a deep plum that matches her hair, with pops of gold and red on her belt, lips, and shoes to really draw attention to herself.

Skin

Hair

Clothes

2 Using the wand tool on your drawing program, select areas and fill them with color. At this stage it's very easy to change the colors that you're using, so if you don't already have a color scheme in mind, play around and see what works best.

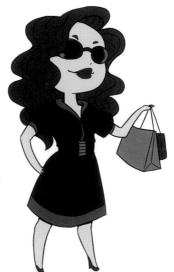

3 Using shadows and highlights, add lighting to your figure. Keep in mind the way that, as Ellie's hair curls, it catches the light in a number of places, and as such has lots of different highlights in it. Makeup is key to being fashionable, so don't forget to add some blusher and lip gloss. Most of the nice detail that's been put into the hair has become lost in the shading process, so use a light pink to change the color of the line art. Using darker shades of the same colors, change the rest of the line art to make it blend in more with the image.

Fashionable accessories

If you really want your fashionista to be in vogue, try looking at recent magazines or on the Internet. Find clothing trends that you really like or, if you want your character to shop at the most fashionable of stores, find out what their bags look like and send them on a shopping spree!

Harajuku is an area in Japan that is famous for the people that gather there every Sunday dressed in their craziest outfits. Nana won't be overlooked when it comes to either style or flamboyance; among everyone that gathers on Jingu Bridge, she's sure to stand out.

Stroll Harajuku with *NANA* the fashionista

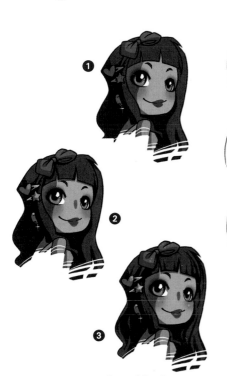

1 Nana lives every day like she's on the runway, so sketch her out with her back to the camera, glancing coyly over her shoulder. Use a bean shape to draw her torso to give her appealing curves.

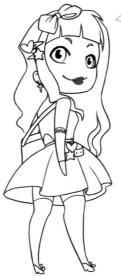

2 Once you've invented your Harajuku outfit, create a new layer and, changing the opacity of your sketch layer so that it doesn't get in the way, add in your line art. To make Nana's lips look natural, don't give them lines, but instead draw them in as a solid block of color. Don't forget to add lots of cute accessories.

Shading complex objects

Begin your shading by focusing on the main shape of the figure and the main light source, and put your shading in the most important areas, such as the curve of the face and the side of the hair (1). Once this is done, you can move on to more detailed shading, such as the light underneath the bangs (2) and the shadows in the creases of fabric. Use the eraser to remove areas where you've already put shading in if needed. Put in a few lines to show the texture of the hair, then add in highlights in areas such as the cheeks, lips, and accessories (3).

3 Play around with a mix of pastel and neon colors. Add highlights to her skin, lips, and accessories to make them light up. Using a soft brush and a very soft red, add blush to Nana's cheeks and apply eye shadow. To make the line art less heavy, pick a color slightly darker than the ones that you've used for the coloring—for example, a slightly darker pink than Nana's dress—and try coloring your line art so that the whole image brightens up again.

Color Palette

Harajuku is all about color and making a statement, so don't worry about going over the top! Neon colors and patterns are all the rage, and Nana manages a perfect balance by wearing mainly pink and blue, which complement each other, and adding flashes of brighter colors through her accessories.

Skin

Hair

Eyes

Clothes

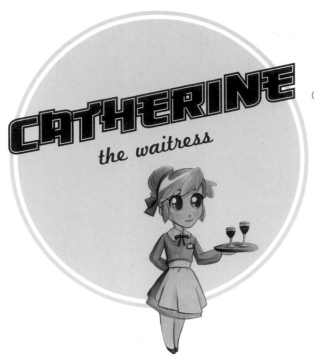

CATHERINE

the waitress

Catherine is a well-mannered, polite, and hardworking waitress at a humble little restaurant. She's always eager to please and is never without a smile.

Style notes

Catherine's pastel colors reflect her gentle, kind personality. The blue eyes and rose-pink attire also help to emphasize her femininity.

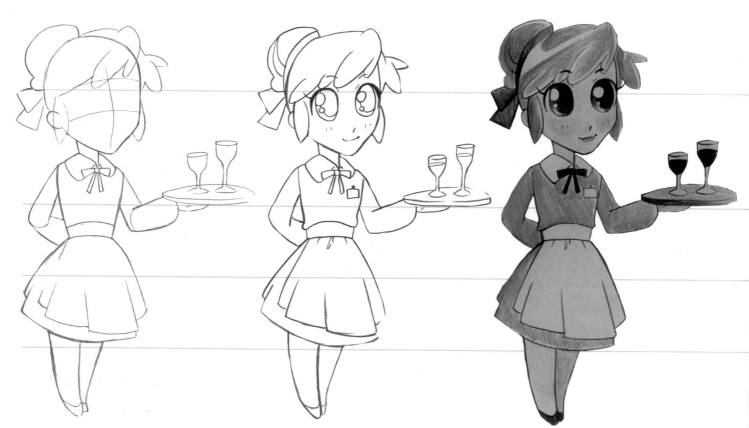

1 Keep the shapes simple. This stage is important to help you create correct and even body proportions.

2 Go over your rough sketch with a black pencil, applying a good amount of pressure to keep your lines dark and smooth. Add in the extra details, such as her name tag, skirt, and apron ruffles.

3 Very gently color her in, making sure that you keep an even pressure on your pencil, which will stop the coloring from coming out streaky or uneven. Leave room for hair and eye highlights, which will be finished later on.

Be gentle with your colored pencils. The key here is to build up your pencil pressure where shadows are needed; this will also make your character look solid and give her depth.

Skin **Eyes**

Hair

Clothes

SERVE UP A TREAT

By simply changing the dishes on her tray, you can add some variety to your character.

Why not have her deliver a delightful sundae (1), cool cocktail (2), or a variety of fast food (3)? Keep the foods bright in color with added highlights to make them look irresistibly delicious!

See also

Traditional media page 12
Chibi animals and objects page 32

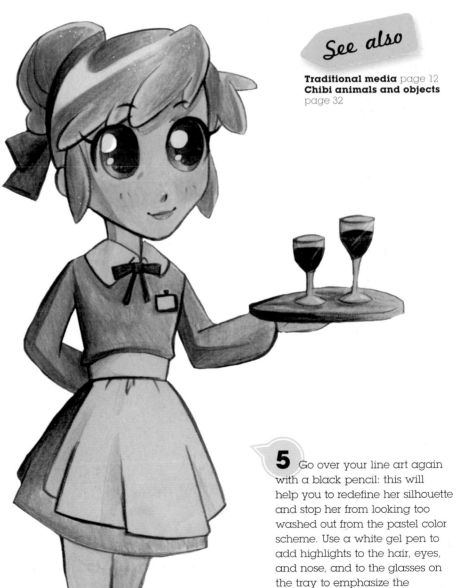

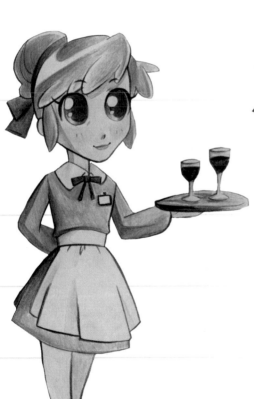

4 When using colored pencils for shading, identify your light source and lightly mark out the shadows. Graduate your pencil from light to dark in these marked-out areas.

5 Go over your line art again with a black pencil: this will help you to redefine her silhouette and stop her from looking too washed out from the pastel color scheme. Use a white gel pen to add highlights to the hair, eyes, and nose, and to the glasses on the tray to emphasize the direction of light.

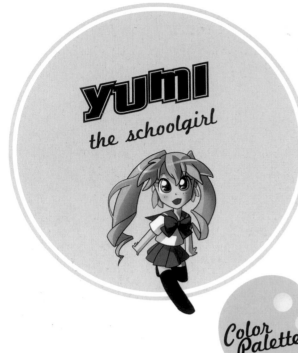

Yumi is a cheerful, excited, and bouncy schoolgirl. She loves hanging out with her friends at lunchtime and teasing the boys in class. She's mischievous, but has a big heart and always means well.

Style notes

Yumi attends school in Japan, where a lot of school uniforms are a common sailor-type design. Take note of the pleated skirt, which you can break down into its component triangle shapes.

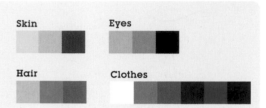

Color Palette

Yumi's uniform is very brightly colored, so to avoid overwhelming her design, try giving her paler skin and a lighter hair color.

Skin

Eyes

Hair

Clothes

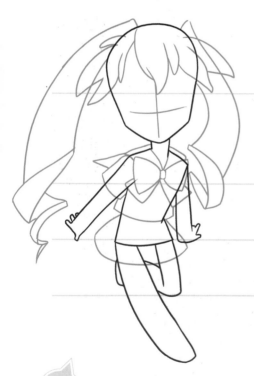

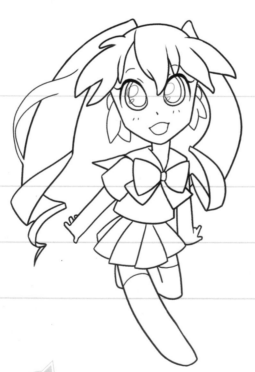

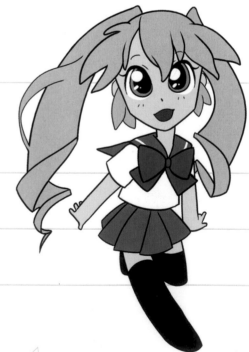

1 Yumi's body is made up of various long rectangles and squares. Always draw the skeleton of the character in this way, so that you get the correct proportions and pose before getting too wrapped up with the details. Then, in a light gray brush, outline her hair and clothing.

2 Draw over your rough sketch, erasing the body underneath the clothing and cleanly marking the clothing out on top. Skirts can be difficult to draw, but just remember that they are made up of triangle shapes. Add in the eyes with a rough guideline for where the light reflects in them.

3 Add in all the colors. Make sure you fill in the eye whites and white line on the sailor collar to give even more character detail.

DRAWING THREE·DIMENSIONAL HAIR

Yumi has big, bouncy hair that can look different at every angle. Give some thought to how your character's hairstyle will look before starting to draw.

When drawing hair, imagine it as a three-dimensional object. Just as you draw circles and cylinders when drawing your figure, try breaking down the shapes of the hair in the same way: it will help you to draw it from various angles regardless of whether you want to show a three-quarter (1), profile (2), or back (3) view.

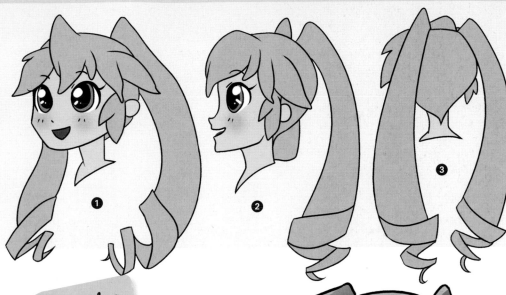

See also

Creative coloring page 26
Dressing your chibi
page 30

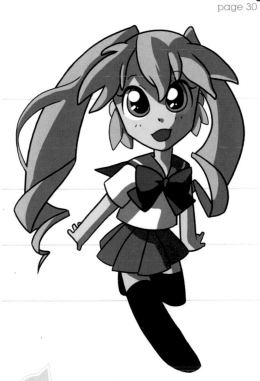

4 You'll have already chosen your light source when you put the reflections in Yumi's eyes, so mark out the shadows in the correct place. Be aware of the shape of the skirt and bow on the uniform, and remember to draw your shadows so that the clothing looks three-dimensional.

5 Brighten up Yumi's face and hair with hot pinks and blush. Add a swooping white line around the hair for an extra highlight. Make sure to use an eraser to fade parts of the highlight to give it a nice, natural gradient.

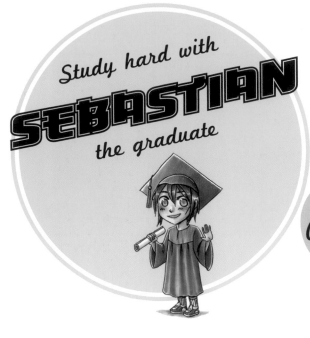

Study hard with **SEBASTIAN** the graduate

Sebastian is an exemplary student, graduating at the top of his class. He's a cheerful guy who likes pranking people with good-natured jokes.

Style notes
Sebastian is known for his chirpy personality. Even in monotone-colored robes, his beaming face shows through.

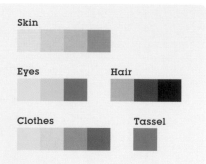

Color Palette

While working, uncap all the markers in your selected color group so that you can quickly move between them. Speed is the key when making gradients with markers.

Skin

Eyes Hair

Clothes Tassel

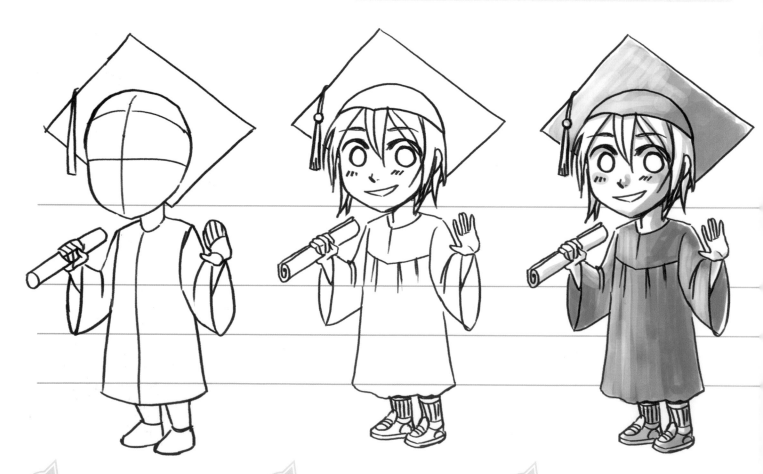

1 Start with simple shapes to build the body. Use a centerline to help keep everything in proportion.

2 Fill out the simple shapes with details, paying special attention to the face.

3 Remember to plan ahead before adding color. Decide on your light source, make a copy of the line art, and shade the figure accordingly to work out where the gradients in color might appear in the next step.

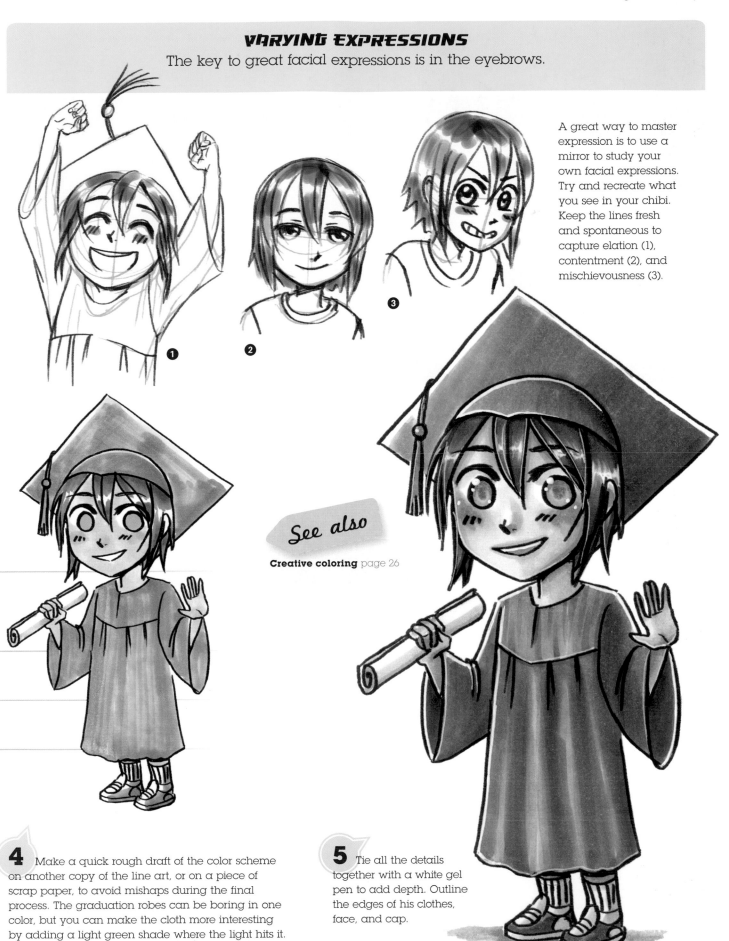

VARYING EXPRESSIONS
The key to great facial expressions is in the eyebrows.

A great way to master expression is to use a mirror to study your own facial expressions. Try and recreate what you see in your chibi. Keep the lines fresh and spontaneous to capture elation (1), contentment (2), and mischievousness (3).

See also

Creative coloring page 26

4 Make a quick rough draft of the color scheme on another copy of the line art, or on a piece of scrap paper, to avoid mishaps during the final process. The graduation robes can be boring in one color, but you can make the cloth more interesting by adding a light green shade where the light hits it.

5 Tie all the details together with a white gel pen to add depth. Outline the edges of his clothes, face, and cap.

Elizabeth the professor is a hardworking gal, but sometimes she bites off more than she can chew. It's probably a symptom of loving her job too much!

Color Palette

Go from dark to light colors to help blend the professor's skin tones and clothes evenly. Work quickly before each layer of ink dries.

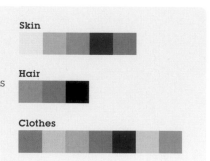

Skin

Hair

Clothes

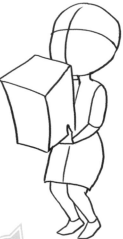

1 Start with simple shapes to build the body, and use a centerline to keep things in proportion. This line also helps give you an idea of the movement of your character.

2 Build on top of the simple shapes, adding details. Pay special attention to the way that the textures on Elizabeth's skirt curve. Before adding color, use a gray marker to work out a light source on a copy of your line art, and add in the shading.

Firm but fair

Elizabeth is a fine teacher, but sometimes she has to get tough! She's not a mean teacher, so keep her expressions stern, yet soft.

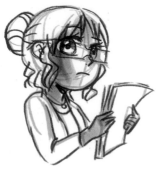

3 Make a quick rough draft of the color scheme on another copy of the line art to avoid any mistakes during the final process. Elizabeth's skirt is tricky. Shade with a gray marker first, then add the pink over it to create depth. Add some minor gray tones to the stack of papers and outline the edges of her clothes and skin with a white gel pen to finish the image. Add in extra details, such as lipstick and blusher.

Give me an "R," give me an "A," give me an "H" for bubbly cheerleader Rah-Rah! Rah-Rah is a sporty, vivacious girl who likes nothing more than to give a big cheer for her favorite teams. Whether with pom-poms, high kicks, or chants, she's always front and center leading the crowd and making some noise.

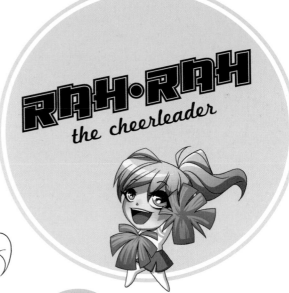

1 Start by sketching out the pose, then pencil in your details over the top. Cheerleaders are always dancing and jumping around, so make sure the pose has plenty of energy and movement to it. Putting her long hair in a ponytail can really help with this because the flow of hair adds a more dynamic edge to her look.

2 Now you can add in your line art. Remember to keep your pen strokes nice and loose to maintain the sense of movement—you don't want her to end up looking static. Using slightly curved lines for her pom-poms will help give them plenty of bounce and puff, too.

Color Palette

It's important for cheerleaders to stand out in a stadium, so using a pair of bright, contrasting colors—in this instance, teal and white—generally works best, and suits Rah-Rah's lively personality down to the ground.

Skin

Hair

Clothes

Style, style, style!

So many seasons, so many outfits! Cheerleaders follow their teams wherever they're playing, and that can mean a gymnasium match in sweltering summer or an outdoor game in freezing winter. Try mixing and matching a few different outfit elements to see what looks best, such as a sweater, a vest, or T-shirt and shorts combo. A girl's got to be prepared for all conditions after all, and there's no reason why practical clothing can't be cute!

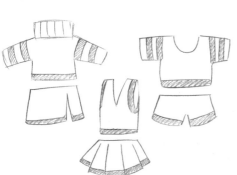

3 Just as with real-life sports-team uniforms, sticking to one or two bright, contrasting colors will work best to make your character stand out. Blonde hair and a rosy glow in Rah-Rah's cheeks really pop out against the teal of her eyes and the pom-poms. Try adding in a couple of stripes on the arm of her jersey, too, which breaks up any solid patches of white.

PEPPER
the dragon says "Baww!"

Pepper is an emotionally charged young dragon. His most distinguishing features are his spots and his tendency to spout fire whenever he's upset!

Style notes

The combination of tears and furrowed brows communicates that Pepper is pretty upset. To emphasize that further, add in a fireball. Pepper's design carries common dragon traits, such as batlike wings, a striped-scale underside, long tail, pudgy belly, fat legs, and pronounced nostrils. Unique features are his single horn and brightly colored spots.

Color Palette

To keep the palette from being entirely blue, add some orange spots: orange is blue's complementary color and will stand out distinctively. The light source, Pepper's fire, is bright and close to the subject, so the shadows are highly contrasted to the lighted areas.

Eyes

Flame

Skin

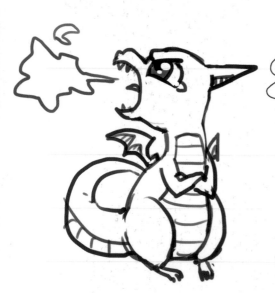

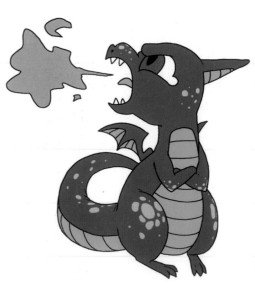

1 The sketch is one of the most fun steps, because you can really go wild with your designing. Start with basic shapes and refine the details once you've got the pose you want. Pepper is about two-and-a-half heads tall and is comprised of a few triangles, but mostly circles and cylinders.

2 Completing the line art gives you a chance to re-evaluate the shapes and details of the character. In this case, the left wing was corrected, the tail's underside was fixed to give it the proper shape, and the feet were fully drawn out.

3 Filling in flat colors can be complicated. Thankfully, that isn't the case with Pepper. Use midtones for your coloring, so that your shading and highlights really pop out in the next step.

THINKING ABOUT HOW DRAGONS MOVE
Dragons are very flexible creatures so don't be afraid to exaggerate their body shapes.

Dragons do all manner of things, from flying (1) to running (3) to curling up quietly (2). In order to show credible motion, familiarize yourself with the way that different animals move—big cats, birds, snakes, and lizards, to name a few. Don't forget that a dragon's range of motion also differs with its size and shape. Small, slender dragons will be more lithe, whereas bigger dragons will likely be more clumsy in their movements.

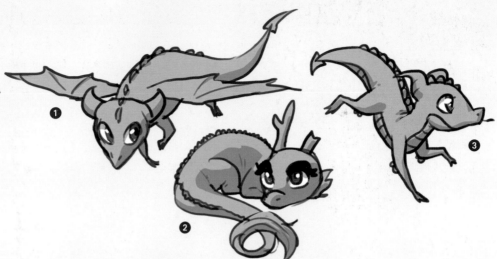

See also

Dynamic drawing page 22

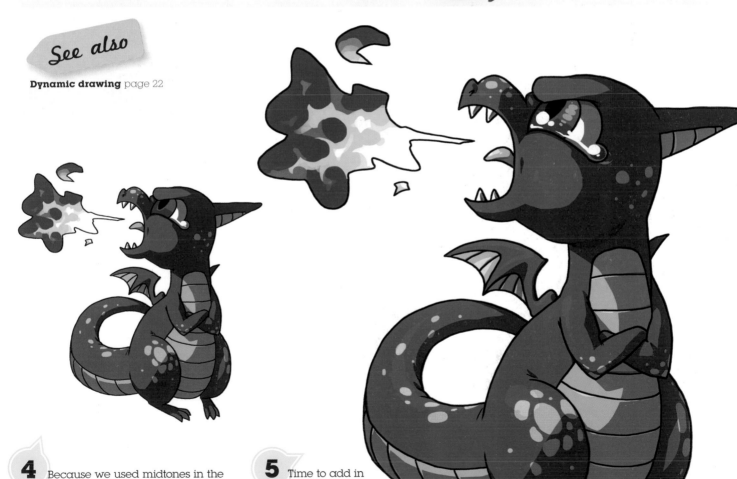

4 Because we used midtones in the previous step, we can get a nice high contrast with the lighting now. And because the light from Pepper's flame is small, Pepper will be mostly in shadow. The flame has no shadows at all, but rather uses a lot of highly saturated colors to appear nice and bright.

5 Time to add in those last few final extras. Use a few darker shadows in areas of a lot of shade, to help really add depth to the shape. Add in highlights, and remember to include some very shiny ones in Pepper's eyes, to show that they are full of angry tears.

RED CAPE
the superhero

Handsome, strong, and downright awesome, Red Cape uses his powers to fight crime and protect the townspeople. He's very charming, confident, and wise.

Style notes
Red Cape is bold, stands out from the crowd, and knows how to get the attention of admirers and villains with his bright, flexible, and practical attire.

Color Palette

Keep the colors simple and clean, with plenty of highlights to emphasize his superhero perfection! Red and blue are popular colors for superheroes because they symbolize nobility and bravery.

Skin **Eyes** **Hair**

Clothes

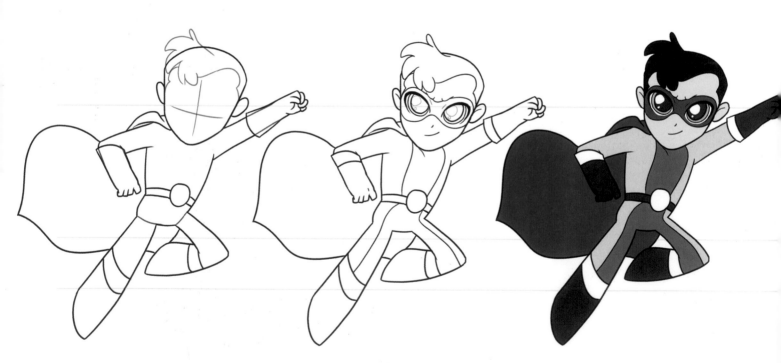

1 Map out the action pose with simple blocks. This stage is important to help you create correct and even body proportions.

2 Go over your linework with thicker lines and add his suit detail and eye mask. Ensure all the lines are connected to each other so that it's quicker and cleaner to fill in with color.

3 Select bright colors and fill Red Cape in. Watch out for corners where the line art meets; sometimes the color won't have filled it in completely. Fill in with your brush tool.

DRAWING ACTION POSES

Try watching action movies and reading comics to get some inspiration
for your superhero poses.

Red Cape is very active, and needs to workout and practice
his fighting moves. Try drawing him in various fighting
(1 and 2) and posturing (3) poses—it will make him look
more vibrant.

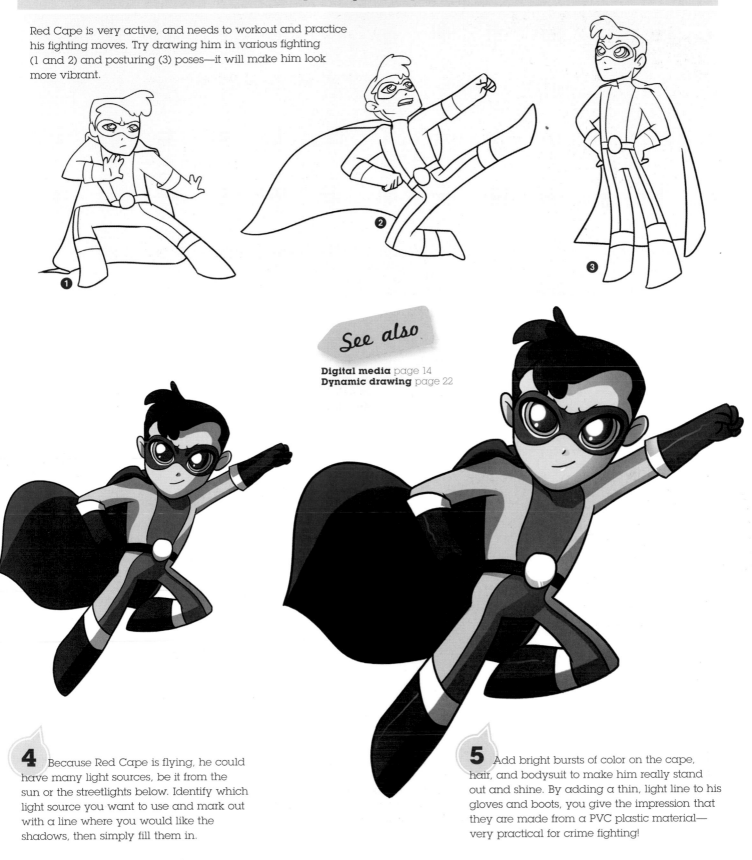

See also

Digital media page 14
Dynamic drawing page 22

4 Because Red Cape is flying, he could
have many light sources, be it from the
sun or the streetlights below. Identify which
light source you want to use and mark out
with a line where you would like the
shadows, then simply fill them in.

5 Add bright bursts of color on the cape,
hair, and bodysuit to make him really stand
out and shine. By adding a thin, light line to his
gloves and boots, you give the impression that
they are made from a PVC plastic material—
very practical for crime fighting!

Strike gold with JOHANNES the alchemist

Johannes would be one of the most famous alchemists around, if only he would stop making such a mess when he works! There's more space to spread out his notes on the floor, but that's only useful so long as he isn't knocking his ingredients over.

Style notes

No one knows where alchemy originated, but it was widely practiced across Europe and Asia in medieval times. As a result, Johannes has traveled far to learn as much as he can, and his clothes reflect that. He wears a mix of heavily patterned court clothes from the countries where he's studied, which make him stand out as someone who's visited all manner of interesting places.

Color Palette

Though Johannes isn't a noble himself, the red and gold in his outfit suggest that he's visited noble courts in the past. The rest of his clothing is practical, but these two rich colors really make his design pop out. The turquoise of his bottles and ingredients contrast with the red in an appealing way.

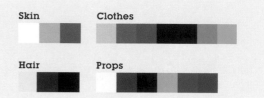

Skin Clothes

Hair Props

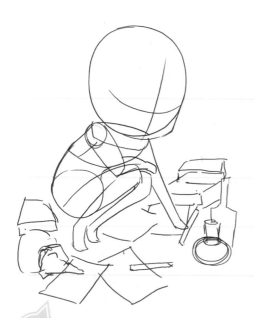

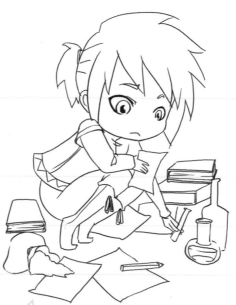

1 Using rectangles and circles, map out the basic shapes of Johannes' body. Sketch in the rest of his environment also, so that you have a guide later on for where everything goes. It doesn't matter if it's very rough at this point, because right now all you want to do is make sure that your proportions and shapes are accurate. Use two lines across the circle of Johannes' head to map out the direction that he's looking in.

2 Clean up your sketch, adding in the details. This is the fun part, because you get to design what he looks like. Make sure that his eyes sit over the line that you drew across his face, so that they're both looking in the same direction. Chibi expressions don't have to be detailed or complicated: you can express much simply through the brows.

3 Go over the sketch with a thicker line to add in the line art. Don't forget to make the lines heavier in areas of shadow, such as the inside points of his hair and sections where his arms are resting on his knees. Even without color and shading, this gives your image depth. In Johannes' case, where he has lots of detail on his clothing, add in geometric shapes and lines to create repeating patterns.

REFLECTIVE GLASS AND TRANSPARENT OBJECTS

Adding shadows and reflections to glass objects can be rather daunting.

Opaque glass (1) only gives off one layer of shade and highlight; however, if the glass is transparent keep in mind to draw in the shadows and highlights on the opposite side too (2). Try looking at some real bottles for reference. Glass is never truly transparent, so try making things more faded the farther back they go. Don't forget that liquids inside will be faded a little by the color of the glass (3). The edges of a bottle are thick, so don't draw liquids all the way up to the edge of the glass.

See also

Chibi animals and objects
page 32

4 Once you've added in your colors and worked out what color scheme you want for your character, you can change the color of the patterns on Johannes' clothes to make them stand out. If you're drawing with traditional pens, do this at the last stage with some different colored gel pens.

5 Since the light source in this image comes from the vial that Johannes is holding, the shading is very dark and comes from a close, central point. As a result, the shadows on the image move out in lots of different directions: be sure to keep an eye on where you're putting them! As the light is very intense, put a thin line of highlights around Johannes' shape, such as on the sides of his cheeks, his legs, and hair. Rather than white, try using a very light blue, because this is the color of the light. Add lots of highlights and sparkles to his eyes to make them look reflective.

Find your prince
with Princess
AMELIA

She may be quite some years away from taking the throne, but Princess Amelia already has grand ideas for when she's queen. When the day comes, she's determined to have the most handsome prince at her side, but until then, no frog is safe!

Style notes
Every princess needs a wardrobe to match up to her busy, courtly days. Amelia's favorite color is pink, but she has a whole collection of blue, green, and gold dresses for whatever she has planned. A pair of matching shoes and a golden crown finishes off the look.

See also

Traditional media page 12
Dressing your chibi page 30

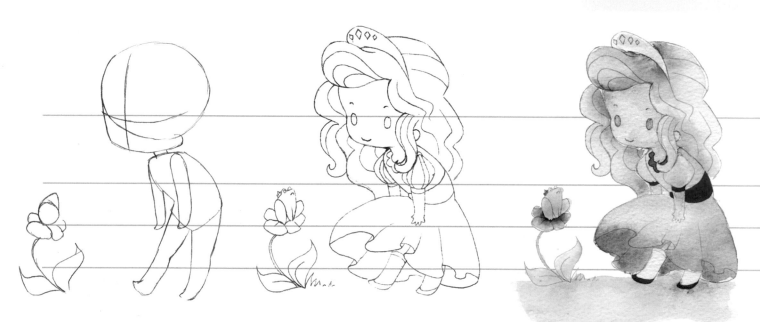

1 Use very basic shapes to sketch out your figure. It doesn't matter if it's very rough: at this point, you're just making sure that you've got the movement, anatomy, and proportions correct. This sketch was started with the round curve that forms her shoulder, back, and left leg, which describes the movement of the rest of the image. The rest of the torso and limbs follow on from this.

2 Because we're painting in watercolors, add details and clean up your sketch with a clean eraser and your pencil. A lot of watercolor papers are quite heavily textured, so don't worry if your lines look wobbly or too faint, as you will be painting over them anyway. Keep your shapes bold and simple to give lots of space for painted colors.

3 Using a thin wash of water, block out areas of color, then apply a light layer of paint. While the paper is still damp, use a richer, slightly darker color and place it in areas of shadow. Don't worry about it spreading, because this will give a nice gradient and areas of shading. Try to use richer colors for shading—for example, Amelia's hair is yellow, but we're using orange for the shading and blue for the shadows under her feet.

Color Palette

Amelia is one of the youngest members of her family, so keep her colors warm and bright to reflect her fun, bubbly personality. Pinks, golds, and reds keep the whole image warm, and balance out the cool colors of the palace lawn and her unfortunate froggy target.

Skin

Hair

Frog

Clothes and crown

PAINTING EYES WITH WATERCOLOR
Make your eyes look deep and vibrant with an extra touch of paint.

To paint eyes, sketch out your shape (1) and apply water to the iris area. While wet, place the lighter color at the base of the eye and a darker color at the top (2). Once dry, paint harder lines with the darker color (3). Leave to dry again, then use a fine brush to add the pupil in the darkest color. Use a white gel pen to add in highlights (4).

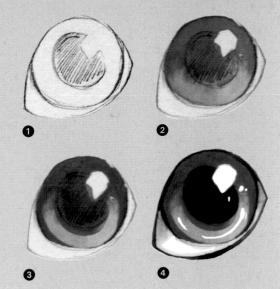

5 Let your last layer of paints dry, then, using a fine brush, add in details such as freckles, the spots on the frog, and extra little gems on the crown. Afterward, use a white gel pen to add in highlights on areas such as the crown, Amelia's cheeks, and the edges of her sash. Black ink outlines can look quite invasive on most watercolor paintings, so instead use a thin brush and brown paint to make your original line art pop back out again.

4 Once your paints have dried, use the same colors as before to paint in more distinct areas of shade. Mix the paints with water on your palette to dilute them a little, but as they're not being mixed with water on the page, they'll still come out darker than your base colors. Add a little water to Amelia's cheeks and dab in some red for a bit of a blush. While you're painting, keep a sheet of paper towel handy and, if your shading's coming out a little too dark, use it to dab some of the color back up again.

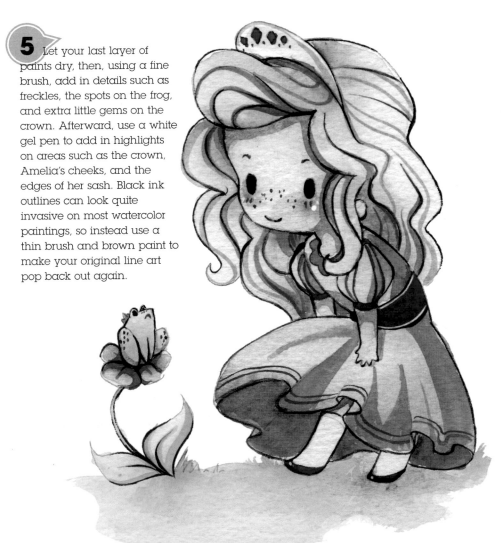

Geisha represent the arts, music, dance, and elegance. Miko is very reserved, but kind and beautiful, and loves to entertain.

Style notes

Geisha are very well behaved and act properly. Miko knows that she must have her feet neatly placed together, with her hands holding fans to make sure that her sleeves do not reveal her forearms.

Color Palette

Miko might be a gentle spirit, but her creative personality reflects in her bright and very feminine kimono. Pinks and cherry blossoms are very important to geisha because they represent springtime, a celebrated season in Japanese culture.

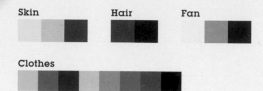

Skin	Hair	Fan

Clothes

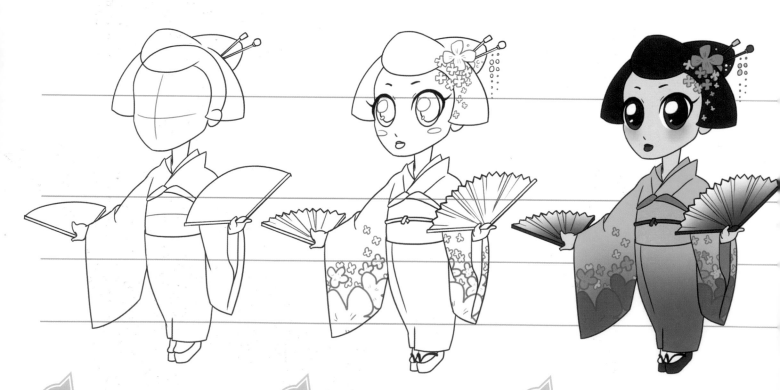

1 Keep the shapes simple. This stage is important to help you create correct and even body proportions.

2 Neatly line over the rough sketch and add in the detail—kimonos can be very detailed. Add any detail to her headdress and clothing in a light gray shade, so that the patterns, when colored, are subtle and delicate.

3 Color in Miko and add gradients to the bottom of her kimono and to her fans, which will help add depth and color to her clothing. Don't forget to add blush to her cheek—makeup is very important.

CULTURAL ACCURACY
Geisha have many different ways of styling their hair.

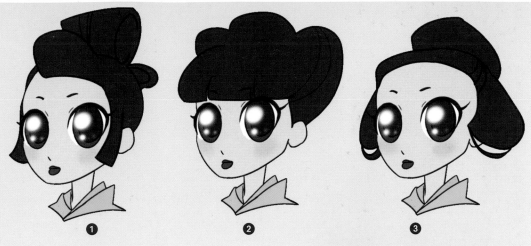

The geisha culture is very particular with the way that it presents itself, so make sure you read a few books on the different ways that geisha wear their hair and clothing. Don't forget that you can add in flowers, chopsticks, or gems to make her look even more special. The hairstyles here are the katsuyama (1), wareshinobu (2), and sakkou (3).

See also

Creative coloring page 26

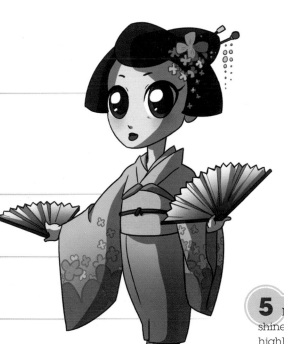

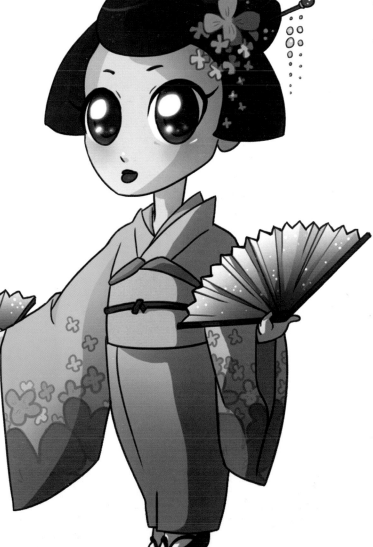

4 Identify the light source and lightly mark out the shadows. Then fill in the areas with your shading color.

5 Now make Miko shine with bright white highlights for her eyes and adornments. If you feel that the highlights are too intense, fade them out a little. Add a pop of bright turquoise to the highlights on her kimono to make her stand out even more.

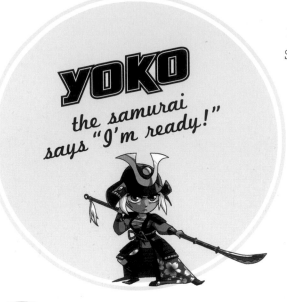

Yoko may be a reserved master of martial arts, but she also takes pride in her appearance. The challenge in this design is combining a pretty yukata with a samurai's armor without making it overly cluttered.

Style notes

There are plenty of cases of female samurai throughout history. Yoko believes more in display than practicality, and is both bold and beautiful, so giving her a flower-patterned yukata and armor adorned with gold details is appropriate. Amplifying certain parts of the costume, such as the rope belt, sleeves, and helmet ornament, helps to exaggerate the look.

Color Palette

Yoko's palette is analogous, which means that the colors are next to each other on the color wheel. Red, white, black, and gold is a very standard color scheme for Asian weapons. Though the Japanese naturally have black hair; in this design, it wouldn't have stood out from the rest of the character, so instead it is white to add to the impact of the look.

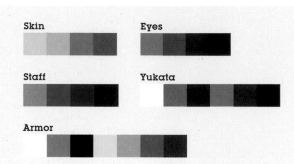

Skin

Eyes

Staff

Yukata

Armor

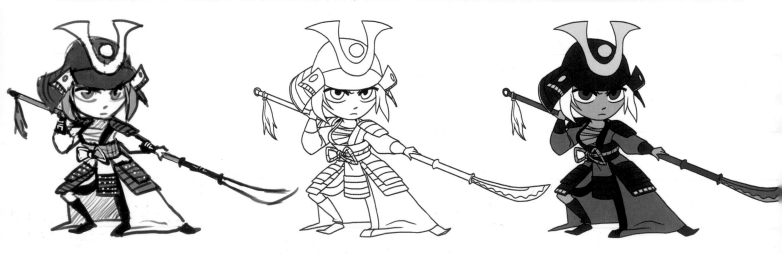

1 Begin with rough shapes and refine the pose. Add details at the end, bearing in mind that you don't have to keep those details when doing the line art. Yoko is created mostly with cylindrical shapes.

2 Now that you've got your basic shape and design, you can go ahead and add, change, or remove details that don't work well. In this case, certain details, such as the designs on her naginata staff, bracers, and the studs on her body armor, have been removed.

3 A few gold studs were added to Yoko's lower body armor in this step. When adding color, use midtones rather than starting with your lightest shades.

HISTORICAL OUTFITS

In Japan, there are numerous types of yukata and kimono to wear, and that's just for the women!

When wearing kimono, which are composed of many layers of fabric, women commonly wear an obi belt to hold it all together, which is tied in a bow at the back (1). Yukata (2) are a much more casual garment. They are worn in the summertime and are very basic, without extra decorative additions, such as fancy obi belts. Samurai armor (3) comes in many different forms with varying levels of complexity.

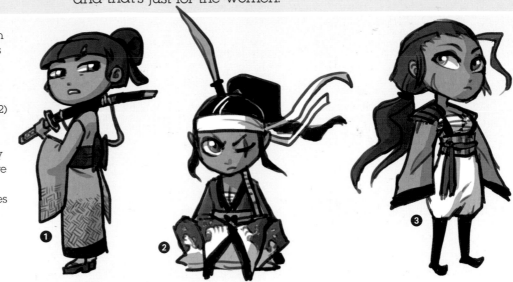

See also

Chibi animals and objects
page 32

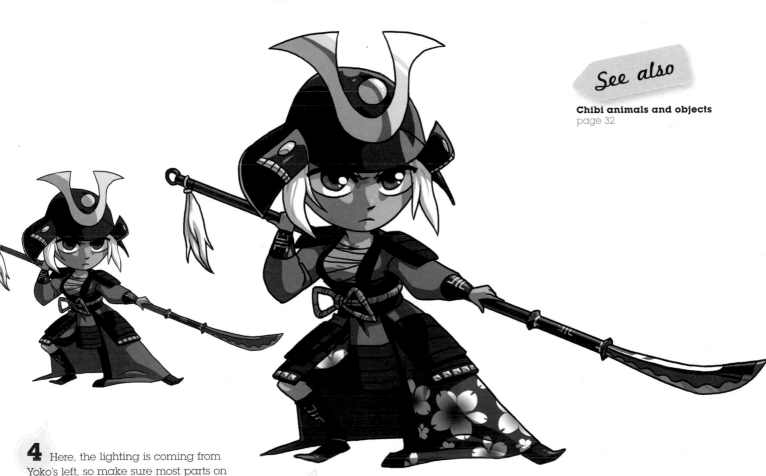

4 Here, the lighting is coming from Yoko's left, so make sure most parts on her right side (our left) are in shadow.

5 Add in design details, such as the flowers on Yoko's yukata, and highlights on her naginata and armor. Enhance the shading by adding in a few darker shadows in the darkest areas, such as the underside of her yukata behind her legs. Metallic objects reflect a lot of light, so don't be afraid to use white as a highlight color.

FLORENZIO
the steampunk mechanic

Florenzio is the onboard mechanic for the airship Larkspur. There's nothing he loves more than fixing it up when it's in port, apart from napping after all that hard work!

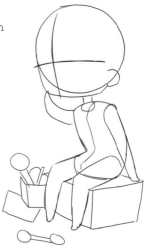

1 Begin by drawing your figure with very basic shapes. Don't worry about adding clothes at this point, but focus on making sure that your figure is in proportion. Double-check that your anatomy is right before going ahead with the next step.

Chibi objects

Create cute, simplified objects and props for your chibi character by first sketching out very rough shapes, such as squares or circles. Then add in your detail and ensure grain on wood or chips and scratches are cute by making them round and chunky.

2 Develop your sketch by adding clothes, facial features, hair, and props. Use thicker lines to show objects' shadows to give them depth. Solid ink outlines make it easier to color. If you're using markers or pencils, these will make it easier for you to stay within the lines, and if you're coloring digitally, then you can use the wand tool to select the areas that you want to fill with color.

3 Rather than using gray or brown to shade, try experimenting with different colors. Purple is a good, neutral shading color that will add depth to your image. Using red tones will give the piece a warm feeling, whereas blue or green will cool it down. You can also add details in your shading, such as fabric folds and scratches, which can look a lot more natural than adding it all in your line art. Adding highlights will really make the image pop.

Color Palette

When you have a character who wears a lot of one color—in Florenzio's case, brown—spruce it up by adding a few very small areas of bright color to make it pop back out again.

Skin

Hair

Clothes

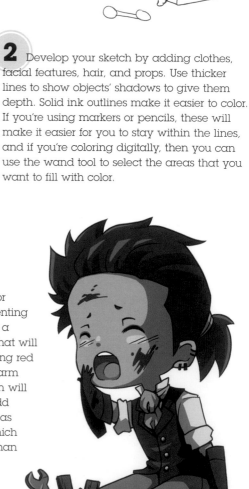

Layla is the captain of the steampunk airship the Larkspur. She may look cute, but don't let that fool you: she works her crew hard, and will expect the same of you!

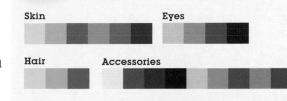

1 Sketch out your figure with simple shapes, making sure that you've got your pose and anatomy right before you add any further detail. Begin with an action line to describe the movement in your pose (see Dynamic drawing, page 22), which will help you to keep everything in proportion. Next, add in the details on your sketch.

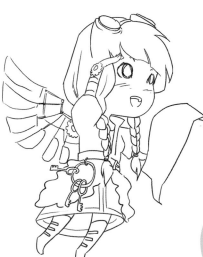

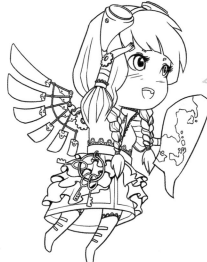

2 Though the main key to drawing chibis is simplicity, it doesn't mean that you can't add lots of detail to your drawing. Use thinner lines to describe details, such as lines in the hair or patterns on fabric, which will keep your image looking simple from a distance. Use varying thick and thin lines to give your image depth.

Color Palette

Layla is a down-to-earth girl, but that doesn't mean that she can't be feminine. She wears practical browns and creams, but expresses herself through her colored hair and accessories.

Skin

Eyes

Hair

Accessories

Drawing braids

Braids can seem daunting to draw, but they're really not so tricky. If you have long hair, try braiding it and looking at it. If you don't, get some colored fabric or thread, and see how each strand overlaps. Braids are generally made up of rhombus shapes that don't quite meet at the points. Try drawing in the direction that the hair goes in with a thinner brush to add detail.

3 Be aware of other characters if you're designing a group. For example, Layla and Florenzio are crewmates, so give them similar or complementing color schemes to make them look cohesive. Put in your shading. Most chibis don't need more than one layer of shadows to keep them light and simple-looking; but when you're adding color to eyes, try adding several different shades to make them really deep.

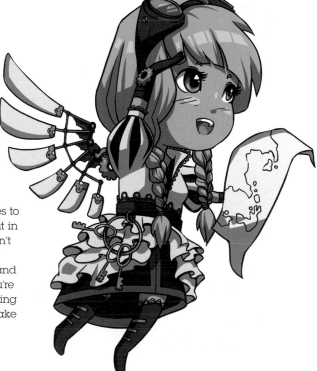

Play around with **AL** the cat

Al may sleep for 21 hours a day, but when he's awake, there's no way to keep him still! Nothing in the house is safe from his playtime, be it his toys or a crumpled-up ball of paper.

Style notes
Cats can come in all colors and markings, from tabbies to calicos and plain old black cats. You can use this wide variety of markings to help give your cat chibis different looks and personalities.

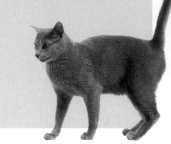

Color Palette

When dealing with gray shades, avoid using a pure gray, and instead use desaturated colors such as red-gray or purple-gray. This way your character will still have some color. Al is a purple-gray with gold eyes because yellow is a complementary color to purple. You can always spruce him up further with a nice bright collar or bow around his neck.

Body

Eyes

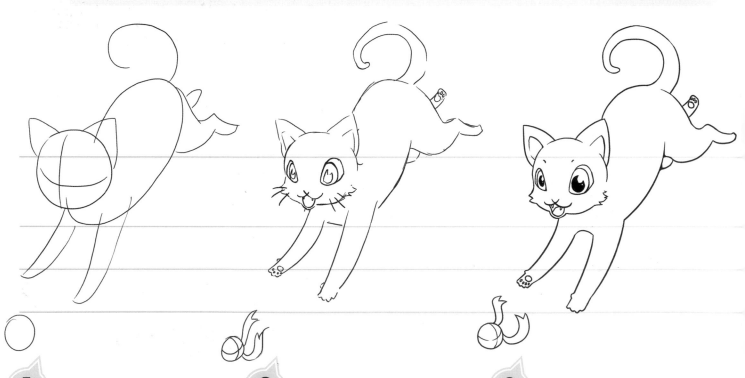

1 Cats—especially chibi cats—are smooth, round creatures, so block out your figure with circles. Use two rounded triangles for the ears and map out the curl of the tail with another line. Be aware of the back legs; they bend differently than the front legs.

2 Flesh out your sketch by adding in facial details and mapping out the rest of the shape of the body. Give him a toy to play with while you're at it. Don't forget to keep his eyes big and bright, and add in his pads where you can see the bottom of his paws.

3 Use a variety of line weights to keep the drawing fluid and fun. Be aware of where your character is looking—for example, since Al is chasing a ball in this drawing, his pupils should be looking toward it.

LONG AND SHORT FUR

Understanding where the fur starts and in which direction it travels can help you to draw it.

See also

Chibi animals and objects
page 32

The idea of drawing long fur can be daunting, but it's not that much harder than drawing a short-haired cat (1). Just keep in mind the way that it flows. Long-haired cats (2) still have short hair on their paws and faces, and the fur is quite sleek across their sides and backs. As a result, you only have to draw tufts of fur where gravity pulls it down on their stomachs and chests, and where it gathers at the elbows, cheeks, ears, and napes.

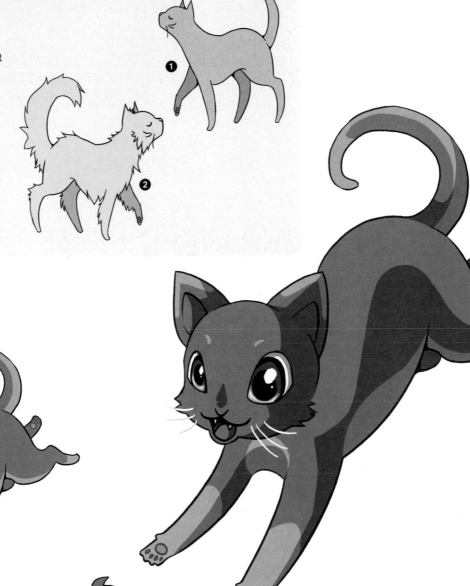

4 Add in your colors, making sure to keep them light. Cats have a variety of markings, so have some fun coming up with a design that's distinctive. Cats don't have brows in the same way that humans do, but you can use markings to suggest where the brows might be, to give a more readable expression.

5 By adding a patch of shading a little way beneath the character, you can give the impression that the character isn't touching the ground, which is a great way to show jumping or flying. Add in several different tones of colors in the eyes to make them deeper, and try coloring in your line art to make the whole image more colorful, rather than using a solid black.

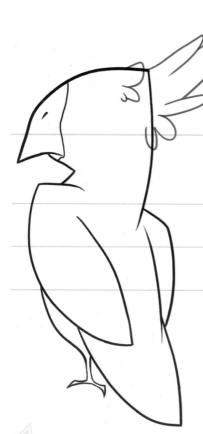

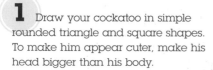

Little Joe is an adorable baby cockatoo with eyes that would melt any heart! He can be mischievous, but also very loving.

Style notes
Joe's pastel colors are accurate to those of real-life cockatoos, but are also bright enough to show off his playful and fun personality.

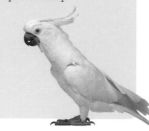

Color Palette

When adding color to your bird drawings, blend all the colors in a gradient: this will make the characters look cuter and more cartoonlike. Pay attention to the yellow tips on Joe's bottom and top feathers.

Feathers

Eyes

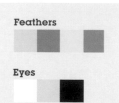

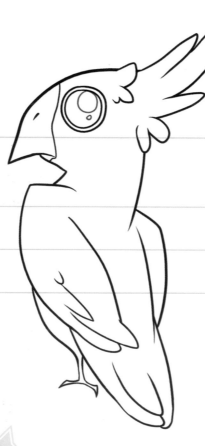

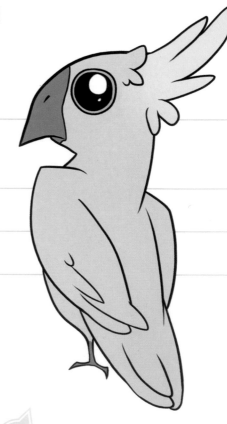

1 Draw your cockatoo in simple rounded triangle and square shapes. To make him appear cuter, make his head bigger than his body.

2 Clean up the lines and connect them all together to make coloring easier in the next step. Add in details such as feather ruffles and eyes.

3 Fill in the line art with pastel tones and, using a soft brush, add bright yellow marks to the feathers, ensuring that they fade out evenly into the pale cream color.

FEATHERED VARIETY
Birds come in all different shapes, sizes, and colors.

The exotic toucan (1) has many bright colors, so make sure you blend them together evenly. As for the common garden robin (2), show its energetic personality by drawing it with its cute little wings spread out. Creating a peacock (3) is a great exercise in blending colors, even though its plumage is a very similar tone all over.

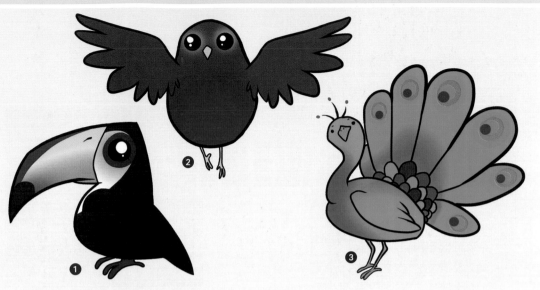

See also

Chibi animals and objects
page 32

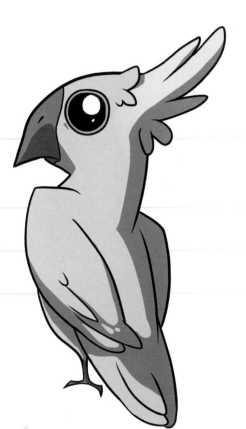

4 Identify the light source and lightly mark out the shadows. Use a dark yellow tone for the shadows, as this will help complement Joe's yellow and cream feathers. Add round feather shapes into your shadows to give the illusion that there are more feathers than you've drawn in the line art.

5 Fade some of the shadows with a soft eraser tool and add highlights to the body to brighten up the whole image. Add white highlights to the beak and eyes.

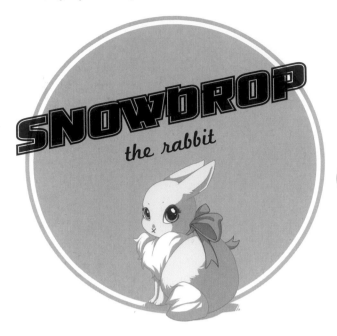

Snowdrop is one of the prettiest girls in her litter, although she doesn't let it go to her head! She loves nothing more than to be cuddled and stroked, and given some fresh vegetables as a treat.

1 The bigger the eyes, the cuter your character will look, so be sure to give Snowdrop large, doelike eyes. A bow around her neck gives her some character, and allows you to add some fresh colors. By giving Snowdrop a soft ruff of fur around her neck and a fluffy tail, you make it clear that she's a girl rabbit. Try giving her some eyelashes as well.

Colored finishing touches

The colors you use for your shading make a real difference. Different colors can convey warmth or cool light, the gender of your character, or more practical elements such as the strength of your light source. A feminine, delicate character can be made distinctive by using light, pastel shading, and stronger characters can be defined with strongly colored, darker shading.

2 To make sure that Snowdrop looks especially soft and elegant, add some light colors to the line art so that it's not too harsh against her light color scheme. Because white won't really show up on this picture, make Snowdrop a very light blue color. This suggests that she's white, but with some interesting colors to look at.

Color Palette

Because Snowdrop is a gentle little creature, her colors are very soft and light. Dove-gray, light-pink, and lavender-purple tones, keep her looking delicate.

Body

Eyes　　　**Ribbon**

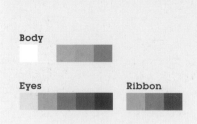

3 Use a light pink to add shading to ensure the image remains soft and Snowdrop looks sweet and feminine. Use oranges and reds for the ribbon and her eyes; orange complements the blue of her fur. Add some shading on the ground to show where she's sitting.

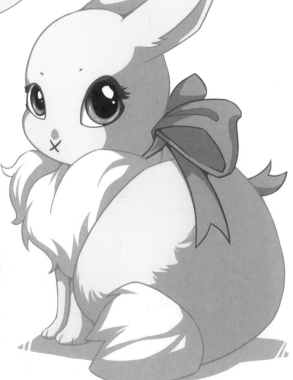

Every cool frog's got his own pad to crash at, and Francoeur's is the coolest around! Hop over to say "Hi" and he'll tell you all the latest buzz from the pond.

FRANCOEUR
the frog

Color Palette

Since Francoeur spends most of his time in and around his pond, he needs a color scheme that will help him blend in. Natural greens and browns make him less easy to spot by predators, and brown freckles across his legs, back, and stomach mimic the shadows in the pond when he's swimming.

Body

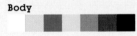

Adapting the pose

Drawing poses for unusually shaped animals may seem intimidating at first, but if you break the body shapes down into circles, triangles, and rectangles, you can work out how to draw them in any pose just by moving these basic shapes. Remember to use photo references to move and pose your character naturally.

1 You can sketch in Francoeur's body with just one circle, but his legs are a bit trickier. Look at photos to see how they bend and move when sitting, and sketch in the basic shapes. Using a soft pencil, sketch in the rest of your figure. Make sure that you've got all the details that you need because you'll be painting straight over this in the next step. Don't worry about being too neat: you won't see the pencil marks once the image is finished.

2 With a medium-size brush, put water over the area that you want to add color to. Don't make it too wet—otherwise, it'll take a long time to dry—but use just enough to make your watercolor paints spread. Then, brush a light green over the whole of the body. While it's still wet, drop in sections of brown and darker green. You can dab back mistakes with a sheet of paper towel.

3 Once the image has dried, add water to small sections where you want to darken the color, such as the insides of the legs and the belly. Add in your darker colors, then leave to dry again. Once dry, use the same colors to add in some areas of hard shading to provide shape. Leave your painting to dry again, then add in more shadows and final details, such as Francoeur's crown and the spots on his legs and belly. Add in some blue shadows to show where he's sitting, then, using a fine brush, add in some line art with a dark brown watercolor.

Pandas really are quite lazy creatures, and Tai Shan is no exception. Give him something comfortable to lie on and plenty of bamboo to munch away at, and he'll happily be there all day!

Style notes
Pandas, like most bears, are very round and soft-looking. Make sure to draw them with as few sharp corners and straight edges as possible—the rounder the better!

1 Using very basic shapes, sketch out Tai Shan's figure. Pandas are very round, so focus on big circles and rounded triangles for his legs. Don't forget to draw what he's lying on; it's important at this early stage to make sure that it looks as though he's actually touching the branch.

2 Flesh out your sketch by adding in facial details, ears, and the rest of the shape of the body. Keep your pencil lines light and soft so that they're easy to erase after painting. Don't forget to give him something to eat in his paws.

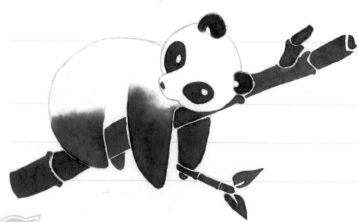

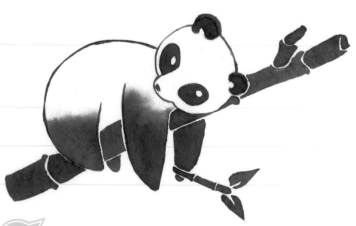

3 Now here's the fun part. Using a wet brush, place water on the area for Tai Shan's legs. Then, while it's still wet, use a paintbrush or an eye dropper to drop your ink onto the paper, and watch it spread, giving a natural gradient. Use the paintbrush to push it around a little, or neaten up the edges of the shape, but be careful not to interrupt the natural spreading of the ink too much. Once dry, paint the same color of ink onto dry paper to block in the rest of the more solid shapes.

4 Using a thin paintbrush, draw line art over the rest of your pencil sketch to give proper definition to your character. Once this is dry, you can erase any visible pencil lines underneath, although it's best to leave the sketch a little longer than you think you should, just to make sure you don't accidentally smudge ink that isn't fully dry.

REALISM, CHIBI, AND SUPERCHIBI

Once you've got the hang of making things chibi, you can go even further to draw superchibis!

What defines chibi largely depends on your style, but as a rule, chibis are three heads high (2), while superchibis (3) are two heads high. This means that the body is roughly the same size as the head. Look at where you can simplify details by using a realistic image (1) as your starting point—for example, making legs shorter and stubbier, making eyes bigger, and ignoring details such as shaggy fur and toes, unless you're exaggerating these for the character.

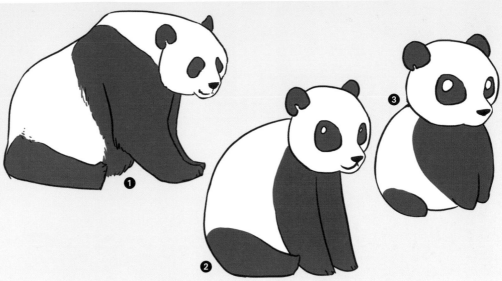

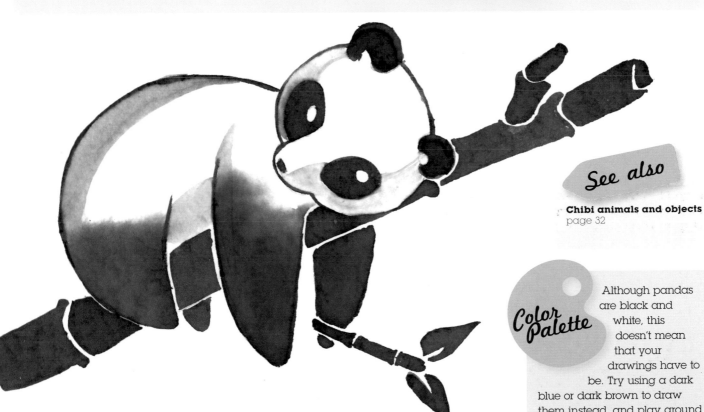

See also

Chibi animals and objects
page 32

5 Once your painting has dried completely, put a little ink on your brush and dilute it with water, to create a lighter tone. Then, very quickly, add some shade to the rest of the body. Take care; some inks can smudge when made wet again, so try to avoid getting too much fresh ink over the line art. If the shading comes out too dark, dab it with a sheet of paper towel while it's still wet to lighten it.

Color Palette

Although pandas are black and white, this doesn't mean that your drawings have to be. Try using a dark blue or dark brown to draw them instead, and play around with different colors for shading. Tai Shan is drawn in a darker shade of blue, because this is a very calm and chilled-out color, just like him.

Body

CHIKTIKKA
the raccoon

A regular in the yard of unsuspecting house owners, Chiktikka is ready to climb his way into your trash and your heart!

Style notes

Raccoons come in all sorts of colors and coat patterns. The most distinctive marking is the "bandit" mask across their eyes, but past this, every raccoon is unique. Try looking up photos of different coat types, and play around with black gloves, striped tails, and brown stripes to make your character unique.

1 Before you start your sketch, look at photos of raccoons to understand their natural shape. Though they're quite round, they're also very sharp and slender in places, so use a mix of circles and triangular shapes to form your figure.

2 Add more detail to your sketch, making sure to capture all the main details, such as the face, expression, and where the markings will go. It doesn't matter if it's messy because you won't see the sketch once you're finished with the next step.

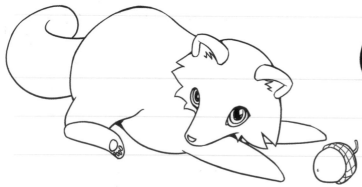

3 The more detail that you've put into your sketch, the easier doing the line art will be, because you don't need to think about what goes where. Make sure you've finished your whole sketch before you even think about putting in your finished lines; otherwise, you may find you are up against anatomy mistakes later on.

4 Looking at photos of real raccoons, add in your colors and markings. Go wild with the markings to come up with something unique and distinctive. Raccoons' eyes are brown, which can be a bit of a dull color, but you can make them really deep and shiny by shading them with richer shades of red and adding in lots of bright highlights.

EXPRESSING EMOTIONS WITH EARS

Ears are one of the most expressive parts of an animal, so make sure to take full advantage of them to express how your character is feeling.

Animals are always listening out for interesting things, so when they're relaxed and not focusing on one thing in particular, one of their ears will be turned backward or to the side to hear what else is going on. However, when they're giving their full attention, both of their ears are doing the same thing. When excited or interested, their ears will turn forward, sticking up straight (1). When sad, they both droop down to the sides (2), and when angry or threatened, their ears flatten back to their skulls, pointing backward (3).

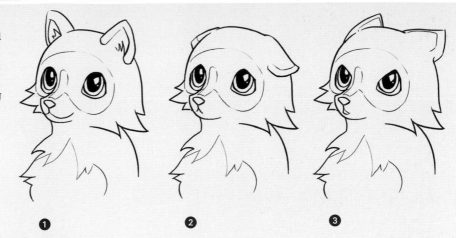

1 **2** **3**

See also

Chibi animals and objects
page 32

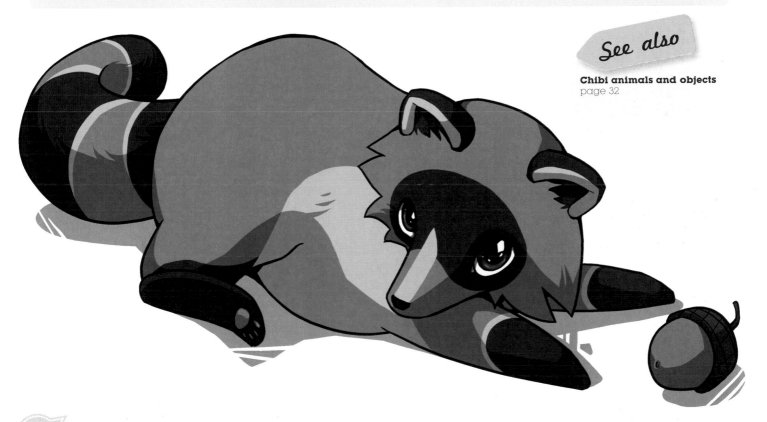

5 Work out where your light source is coming from—in this case, it's just above and slightly behind Chiktikka. Block in the main shadows, then add in a few rougher strokes of shading on the tail, face, and hip to give the impression of fluffy fur. Don't forget to add in some shadows beneath him to show where he's lying on the floor.

Color Palette

Although raccoons are commonly known to be gray, it's not uncommon to find brown or red raccoons. Even though Chiktikka is a common gray raccoon, stay away from using true gray shades, and instead lean toward a brown-gray or blue-gray, to give him a little color and make him look more realistic.

Body **Eyes** **Acorn**

There's only one thing better in life than being a cat, and that's being a dog! Whether it's being played with, being given treats, or going for a run, there isn't a bit of life that Ace doesn't love—and he's always full of energy for a new game or adventure.

Style notes
Ace is a bit of a mutt, which means that he doesn't have the markings of any particular breed. His dark socks and ears that are a little too big and flop over at the ends make Ace just plain adorable.

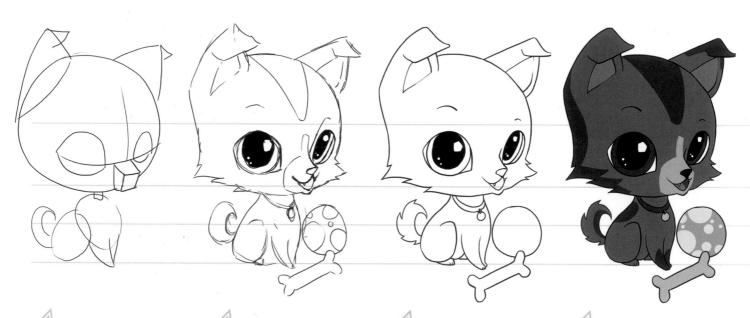

1 Ace's body is soft and round, so start by blocking him out in circles, with triangles for his ears. Draw in a cross over his face to show where his eyes will sit. Once you've got these basics, add a square just beneath the line of his eyes for his muzzle. This might take a few attempts to get right, as it can be tricky to achieve the correct perspective; but once you've got the hang of it, you'll get it perfectly every time.

2 Using very rough lines—it doesn't matter if you're a little messy at this stage—sketch the details of Ace's body around your basic skeleton. Give him big, inviting eyes and a soft, curly tail, as well as a few tufts of fur at his cheeks to make him all the more appealing.

3 Go over your sketch with a pen or brush to add some clean line art. If you missed anything out in the sketch stage, don't forget to add it in to your drawing now.

4 With your line art in, add in your flat colors. Dogs have a range of colors and appealing markings, so use this opportunity to get creative with your character design. Don't forget that, even with props, you should think about using complementary colors to try to make the whole image come together.

Color Palette

The most natural colors for a dog are brown or gray, and because Ace's personality is quite lively, brown is the best choice for him. A mix of darker and lighter patches adds a little variation, and the blue of his eyes and collar add a pop of interest to make him stand out.

Body

See also

Chibi animals and objects
page 32

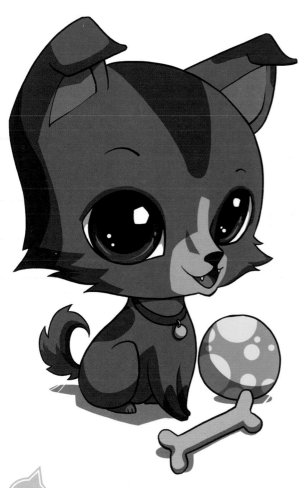

5 Shading will give your image life and make it three-dimensional. Use lots of long, curved lines and keep in mind where your light source is, so that all of your shadows are in the same place. Add some highlights and different colors to Ace's eyes to make them full of life, and add shadows beneath him and his toys to show where he's in contact with the floor.

DIFFERENT DOG BREEDS
Appearances vary massively from one dog breed to another.

It's simple to draw a standard, mutt-type dog (1), but there are many breeds you can draw on for inspiration. Large dogs, such as the Borzoi (2), can be elongated and elegant, or, as in the case of the English Bull Terrier (3), they can be blocky and square. Small dogs can be distinctive too—Chihuahuas (4) are delicate and rounded, whereas Pugs (5) are rectangular. Use photos for reference, and break each dog down into its key shapes.

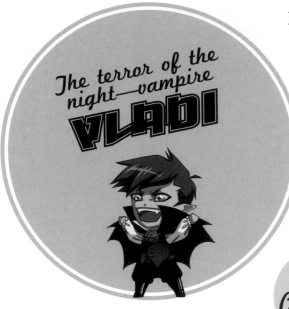

The terror of the night—vampire **VLADI**

Little brother to Count Cain, Vladi is a young vampire whose sense of adventure is even bigger than his fangs! Constantly trying to escape his big brother's shadow, he also has a tendency to lose his temper when things don't go his way.

Style notes

Vampires are often closely associated with predatory animals like bats, so pointed shapes and angles lend themselves perfectly to their design. Viscount Vladi is no exception, so keep him looking sharp!

Color Palette

Being an aristocrat and a creature of the night, Vladi suits rich, cold colors, like purples and blues, while a flash of gold for his eyes and cravat pin will add a pop of contrast.

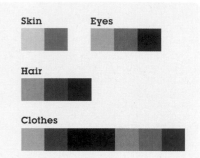

Skin Eyes

Hair

Clothes

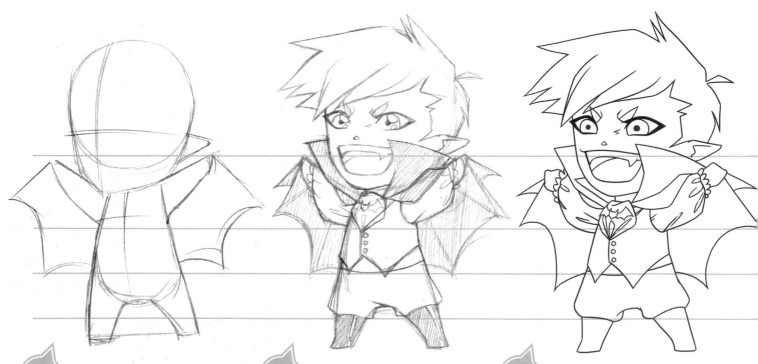

1 Begin by planning Vladi's batlike stance with simple shapes for the body and a few lines to show where his cape will go. The fabric is a prop for his pose, so it's important to get a sense of how it's going to tie in from the very start.

2 Flesh out your initial sketch with Vladi's hair, clothing, and expression. You can even add some rough pencil shading to show where you're going to put the darkest areas of color and to help you map out where the highlights on accessories, such as his boots, will go.

3 Once you start on your line art, you can still add in details, such as the definition on his hands and the creases in his sleeves. Another technique you can use is colored line art. Try using brown instead of black to draw in Vladi's pupils: the effect will be much bolder than adding a pupil in at the coloring stage, but will still blend in well with the iris.

EXAGGERATED EXPRESSIONS

Use brows, blushes, and other visual symbols to make your expressions really exaggerated and readable.

Because he's still only a child, Vladi often lets his emotions get the better of him, and this shows on his face. Because of this, his expressions have a tendency to be exaggerated and melodramatic, with lots of body movement (1), brow movement (2), and visualizations, such as temple veins (3), to emphasize his moods.

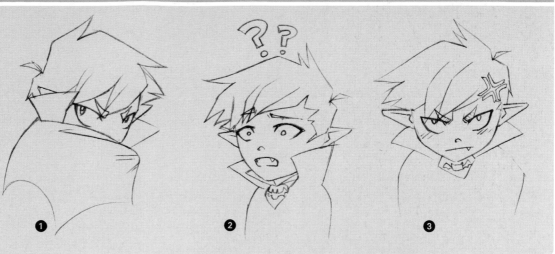

1 **2** **3**

See also

Dressing your chibi
page 30

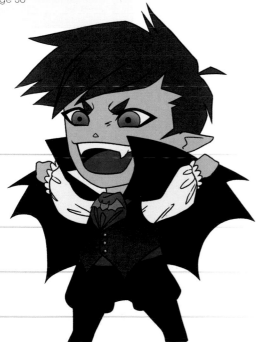

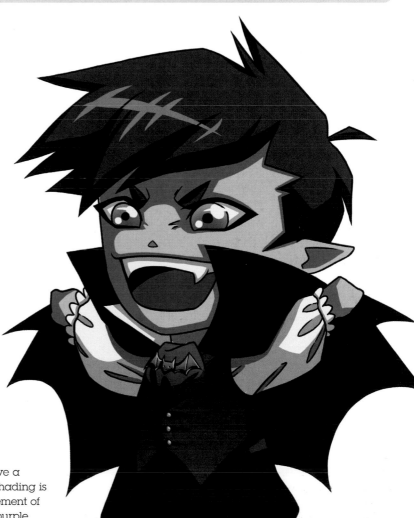

4 Now you can start filling in the colors. The colors and fabrics of Vladi's clothes are rich and expensive, so use gradients to add more saturated tones and create the effect of silks and velvets, the Viscount's favorite choices of cloth!

5 Lighting can give a dramatic finish, so shading is a very important element of Vladi's design. Use purple instead of brown or gray for your shadows to bring out the pale glow of his skin. You can also use a very light color or a simple white to pick out the highlights on his cravat pin and boots for a glossy, polished look.

WILLIAM
the pirate cabin boy

If William doesn't sound much like a pirate's name, it's because . . . well . . . it isn't. Not born to pirate stock, William's much more interested in exploring foreign lands than swashbuckling, but really does try to fit in where he can.

Color Palette

William's wardrobe is mostly blue, which complements his blond hair, and the red sash that he wears is a tribute to his captain, the fearless Captain Isabella.

Skin				Eyes			

Clothes							

Telescope							

1 Rather than focusing on details first, make sure to use very basic shapes to block out your character's figure. Use circles, cylinders, and elongated triangles to mark in the basic body and props. Use a simple cross to mark out the direction that he is looking in.

2 Start to add in detail, including clothes, a face, and the features of the props, then go over all this with your line art. Use thicker lines in corners to add depth, and add smaller details, such as the cross-shaped stitching on the trousers, cuffs, and shirt.

Drawing perspective

Even in chibi drawings, you're going to have to deal with perspective. For William, for example, you'll need to get it right on his telescope. It's not just props, however; perspective will come into play on legs and arms, and even torsos, To draw limbs in perspective, break them down into basic cylinders. Drawing rings around these cylinders will help you get the curve of things, such as cuffs, collars, and accessories.

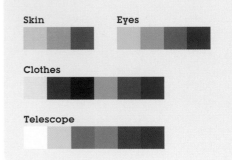

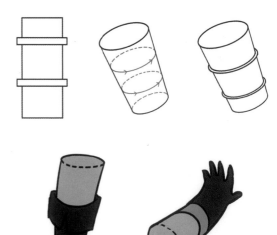

3 William wears mostly blue with a splash of red, which matches and complements his eye color. Use red on the stitching on his clothes to tie it all together. Use a purple for the shading to add a little more color. Keep in mind where your light source is—in this case, above and slightly to the right—and add in shadows and highlights accordingly. Use different shades of blue in the eyes to liven them up.

Isabella wasn't daunted by the task of commandeering a ship and putting together the greatest crew on the seas. She is feared by every other pirate on the seas, and loves nothing more than the energy of the ocean in the middle of a tempest.

Drawing the elements

Keep in mind when drawing in elements that they move in a very smooth, fluid way: draw in a line to show the direction first, then draw around that.

Water comes apart easily, so draw lots of splashes and droplets.

Fire is quite angular, and breaks away at the tip of the shape.

Keep wind smooth and curved, and draw in white lines to show the direction it's blowing in.

1 Start off by focusing on basic shapes and lines to block out your figure. Make sure Isabella's back and legs have a natural curve: the rest of the figure should flow from this first line.

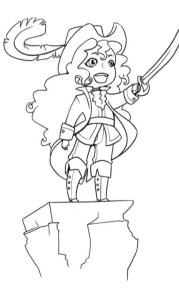

2 Draw in the rest of the sketch, adding in clothes and props. Use long, fluid lines to keep the movement. Make sure that Isabella's hair, coat, and the feather on her hat are blowing in the wind. Using your detailed sketch as a guide, draw in your line art. Use thicker lines for a sense of depth, and try to draw lines in one attempt, to keep them curved and flowing naturally. Add in details such as the buttons on her boots and cuffs.

Color Palette

When the sea is your mistress, the best color to wear is something that shows up against that endless stretch of blue. Gold and red are rich, luxurious colors fit for a captain and really stand out against the ocean. The blue feather in Isabella's hat matches the color of the uniforms of her crew members.

Skin | **Eyes**

Clothes

Ocean and rock

3 Block in the colors on Isabella's figure and the rock. Try different ways of fading out the rock base so that it doesn't end in a straight line—for example, by using shapes to suggest the texture of the rock. Add in the shading, keeping in mind where the light is coming from, then add blush in Isabella's cheeks and highlights on her cheeks, eyes, sword, buttons, and boots. As her hair is quite dark, use highlights to make it pop back out again. Use the advice given in "Drawing the elements" to draw the sea.

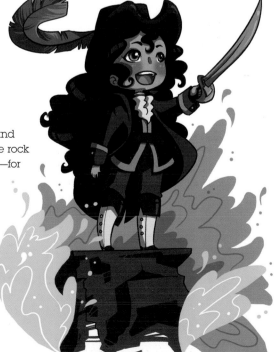

Sail the seas with **ISABELLA** *the pirate captain*

Shake a leg with **FROUFROU** the can-can dancer

Everybody likes a good knees-up, but no one more so than Froufrou! Always a bit of a party girl, Froufrou loves to dress up in the latest Parisian fashions and cut loose on the dance floor. In a whirl of frills and feathers, she's sure to capture the heart of every man in the room.

Style notes
Can-can dancers wear big skirts with lots of ruffles to emphasize the kicks and twirls in their dancing. The more frills on Froufrou's petticoats, and the bigger the skirt she's wearing, the better!

Color Palette
Red, pink, and cream are the perfect colors for a lively, romantic girl like Froufrou. A pop of blue in her eyes makes them stand out.

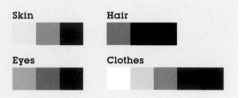

Skin

Hair

Eyes

Clothes

See also

Dressing your chibi
page 30

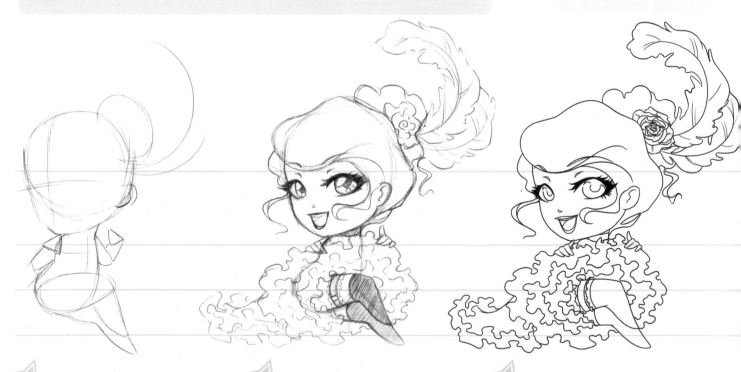

1 Start by using basic shapes to construct the body. Froufrou's pose is coy and playful, so make sure you capture that dynamic twist with the head and the legs facing in opposite directions.

2 With the shape of the body drawn, you can now start putting in her costume and hair. The stray curls are drawn with loose, sweeping lines to keep them full of movement. Let your pencil wander a bit on the edges of the feathers and frills, too: the more varied the line, the more interesting it is to look at.

3 Now that the details are all sketched in, it's time to neaten them up with some line art. Remember to keep your lines for this stage as loose and fluid as your pencil lines to ensure that none of the movement is lost and that your picture doesn't end up too static.

VINTAGE HAIRSTYLES

Add a touch of vintage glamor to your character with some classy historical hairstyles.

Women didn't only wear their hair in curls in the old days; there is a great variety of fancy up-dos to choose from. Why not experiment by trying out styles like buns (1), braids (2), or tied-back layers (3) on your character? Have a look at old photographs and paintings for inspiration.

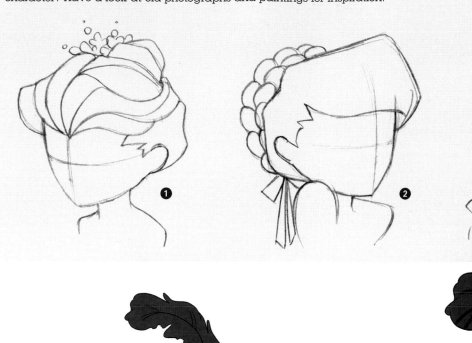

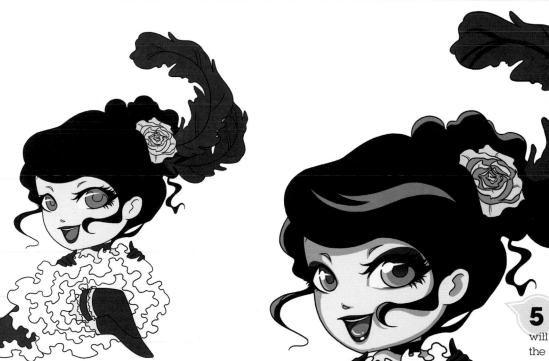

4 Time to start laying down your flats. Try to base your palette around a simple theme. Don't be afraid to experiment with the odd splash of other colors in there, too. If all your colors complement each other, the end effect will work well.

5 Shading and highlights will really bring Froufrou off of the page. Pay extra attention to little details, such as the eyes and lips, where the highlights are brighter and sharper, to make them look glossy. You can also add in further touches, such as a couple of creases on her stockings to show the bend in her knee or makeup to make her look even more glamorous.

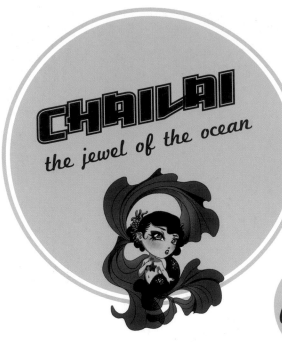

Beautiful mermaid Chailai loves to spend her days swimming the Pacific Ocean and showing off her long, flowing fins. She's a feisty little lady, and is just as tough as she is colorful. She'll never back down from a fight!

Style notes

Mermaids have always been popular in fantasy stories, and are portrayed as unearthly, elegant creatures, so make the fins, hair, and features on your character as fancy as you like! Being half fish, mermaids are also graceful movers, so use lots of curves to make the fins and the tail flow.

Color Palette

Chailai's vibrant colors are based on those of the Betta fish, also sometimes called Siamese fighting fish. The vivid reds and blues suit her bold personality, and have a punchy visual impact that complements the more delicate aspects of her design.

Body

Eyes

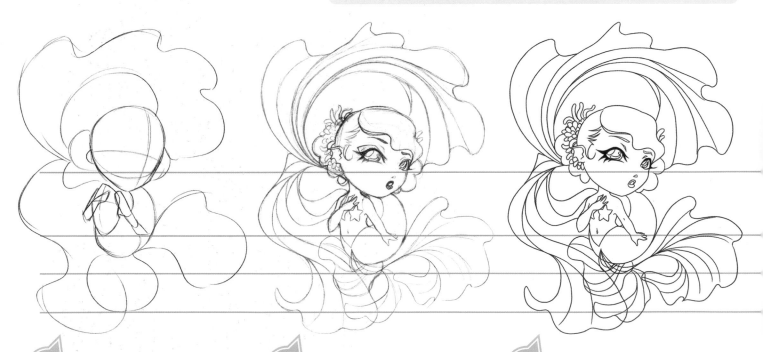

1 Start with a loose sketch of Chailai's body. At this point, draw the fins with just a few lines to give you a rough idea of where they will go and how big they will be—don't worry about adding detail yet.

2 One of the best ways to get the fins to flow nicely is to keep all your pencil strokes going in the same direction. For the twists and curls in her tail, start your lines from one point of origin and draw outward to form a fan shape to create the effect of the fins spreading out. Little sea-life accessories in her hair, such as anemones and pieces of coral, can really help emphasize her underwater nature.

3 Curves can be difficult to line art smoothly, especially when you have already drawn them once and can't seem to do it again! If you find you are struggling to create a curve with one stroke, try drawing a series of curves that follow your sketch line around and then erase the loose ends and join them up.

ALTERNATIVE TAILS
Be imaginative when it comes to designing your mermaid character.

Everyone recognizes the classic mermaid with a standard fish tail, but why not spice up your character designs by using ideas from more exotic kinds of sea creatures? Lionfish (1), electric eels (2), and even jellyfish (3) can inspire some exciting new looks for your mermaid. Experiment with a few different kinds of fish and see what you can come up with.

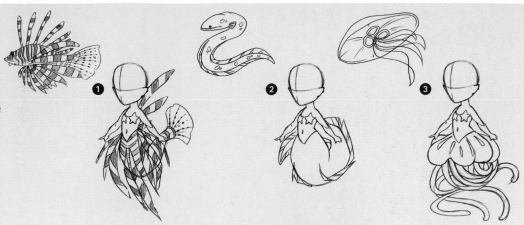

See also

Dynamic drawing page 22
Chibi animals and objects page 32

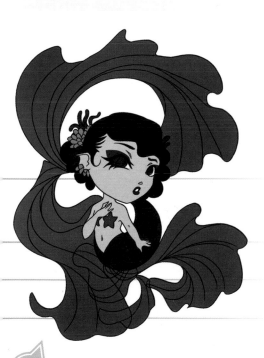

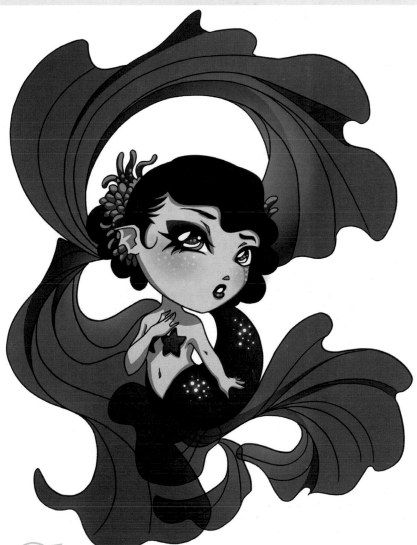

4 Because mermaids are fantasy creatures, you can be as creative with choosing your colors as you like. Using complementary shades for the skin and the tail generally looks best, and making the fins a lighter color than the rest of the body is a good way to make them appear more transparent.

5 For the final touches, darken the colors in the places where Chailai's fins overlap to give them depth and make them look even more see-through. Adding a few white spots on her tail with a soft brush will give her a glowy glimmer reminiscent of fish scales.

Travel the world with *MAURICE* the explorer

According to the other professors at Cambridge University, their colleague Maurice went missing years ago. Little do they know that he's been making a world of discoveries in the unexplored jungles of the world, trading in a life of books for a life of adventures!

Style notes

It's tough work when you're traveling through jungles and mountains, but Maurice has both comfort and style figured out when it comes to his wardrobe. A tough jacket and trousers fend off the worst of the weather, and for everything else, his pith helmet does the job.

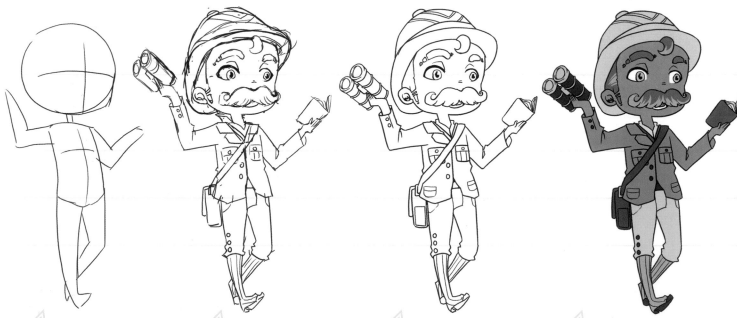

1 The first step is the most important, so make sure to keep your shapes basic and your lines smooth, to give a sense of movement while you work out your basic pose. Create your figure using circles, rectangles, and other simple shapes. See how Maurice's right foot is leading the pose, so the rest of his figure follows slightly behind it.

2 Once you've got your basic shapes, you can really have fun elaborating on your sketch. Don't be afraid to sketch messily, but keep your pencil work light so that it's easy to erase later, and really have fun trying out different outfits and expressions.

3 Now that you're fully happy with your sketch, clean it up with some line art. If you're drawing on paper, you can use a pen or a brush and ink, and wait until dry before erasing your pencil lines. If you're using a digital program, make a new layer for your line art so that it's kept separate from your sketch. Try to use long, sweeping lines so that you don't lose any of the movement from your sketch.

4 With your line art finished, add in your colors. Since the outfit that Maurice is wearing is a historical one, your choice of main colors is restricted; however, you can add in little pops of color to make him stand out, such as in his eyes, on his book, on the waistcoat under his jacket, and on the silk band around his helmet.

DRAWING FEET AND BOOTS

Drawing feet can seem tricky, but it is really quite simple.

A great thing about drawing in chibi style is that a lot of things are simplified, so you can focus on the shapes of objects without worrying about small details (1). There are two main joints where feet bend, one at the ankle and one at the toes. Picture them as a wedge shape when drawing in the underside of the sole (2), and for a little bit of extra detail, try adding in the gap between the heel and sole of the boot (3).

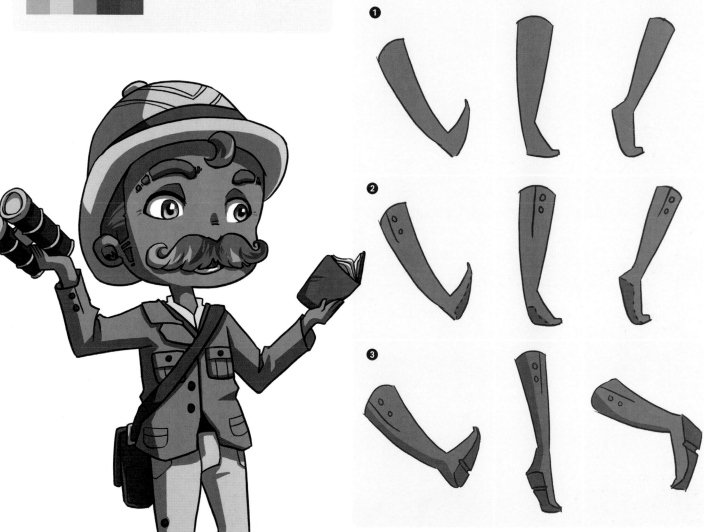

5 Shading will make your image three-dimensional, so don't be afraid to put large amounts of it in where needed. For example, the brim of Maurice's helmet is quite broad, so put in a large stripe of shadow underneath it where it shelters his forehead. You can also use the shading to describe the way that his trousers fold where they're tucked into his boots and the scuffs on his travel journal.

See also

Dressing your chibi
page 30

Raymond doesn't feel much need for adventure in his life: all he needs is a quiet field, some treats to eat, and a patch of sun to doze the day away in.

Style notes
Convey a gentle, placid personality by using a solid standing pose and focusing on the eyes to create a mild expression.

Color Palette

Take inspiration from real life, then adjust it to your image. With russet brown as a base, use a lighter, more saturated version to make sure that Raymond still looks colorful. Using gray, not black, on his ears and nose stops these details from being too overpowering in this soft image.

Body

Mane and tail

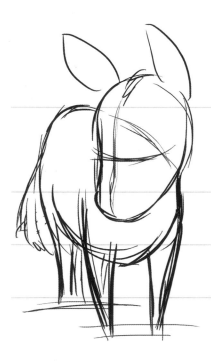

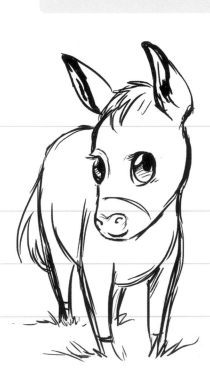

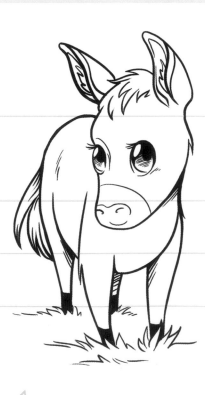

1 Raymond's short, tapered legs are cute, but also help to create a solid, stationary pose. Sketch in the full shape of the body, even where hidden by the head, to make sure everything's in the right place.

2 Develop the details. Big, round, expressive eyes give this character his sweet, placid personality. Try to make your lines flowing curves, to keep the shape rounded and simple.

3 Tidy up the lines. Raymond is made of simple shapes, so add small details at this stage—such as a tiny bit of light hatching in areas of shadow—to help add interest. Keep in mind at all times where your light is coming from, so that your light source is consistent.

DRAWING STYLIZED ANIMALS

The extent to which you stylize animal characters is up to you, but it can give them lots of personality.

There are many ways to stylize an animal. Look up lots of reference pictures, then try out some options. Think about how much detail to use, what sort of shapes the animals are made of, and what sort of expressions you want them to have. Use manes or fur to give a hint of a human-esque hairstyle (1), give them large, expressive eyes (2), or even eyelashes (3).

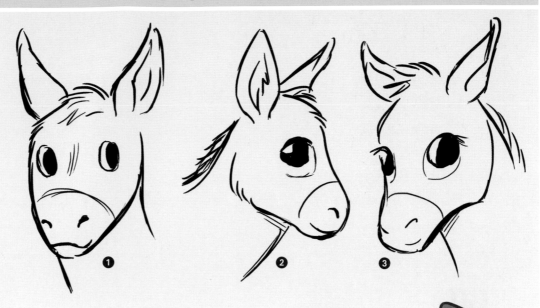

See also

Chibi animals and objects
page 32

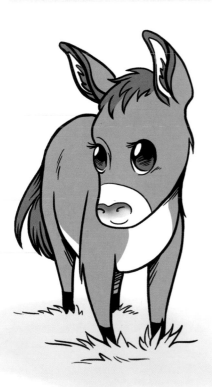

5 Use a single, warm color for your shading. Try soft shading rather than cel shading, to add to the gentle feel. Use some artistic license on the shadow he casts on the ground, fading it out so it isn't too obtrusive in the picture.

4 Fill in the basic colors. Use blended edges sparingly—for example, on Raymond's nose—to give a sweet, soft touch while still keeping the colors simple and clean.

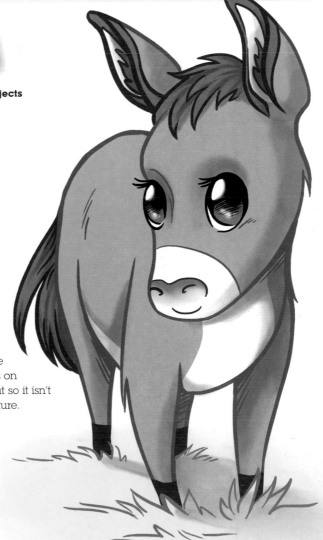

Splashing in puddles with **titi** the fawn

Gigi is full of energy and excited to discover the world, especially after the rain, when it's full of puddles to jump in!

Style notes

For energetic characters, use a pose that catches them in the middle of a movement, to convey a bouncy personality. Choose a pose that also keeps important design elements visible, such as a fawn's spots and cute tail.

Color Palette

There's no rule that says your animal characters have to be colored naturally. Try something bright, and add accent colors for impact, like Gigi's turquoise eyes. Keep the contrast recognizable, though: Gigi's stomach is still light and her nose still dark, like a real fawn.

Body					Eyes	

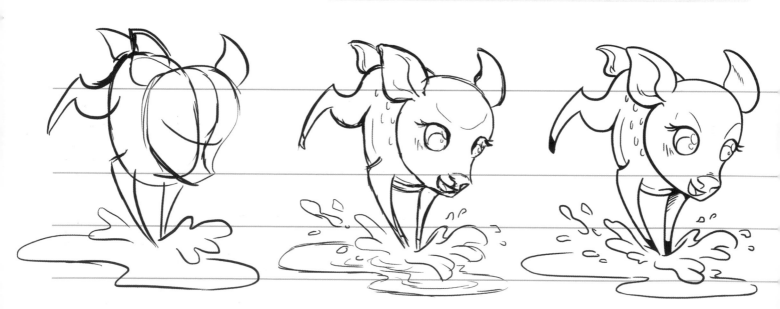

1 When sketching characters in motion, think about what position the body will be in before you draw in the limbs. Real fawns have very long legs: make Gigi's thin and tapered, but keep normal chibi proportions with the rest of her body and head.

2 Sketch in details. It can be tricky to apply expressions to animal characters, but spend some time on this in the sketch stage, to ensure the facial features and expression feel right. You'll get the hang of it quickly.

3 Ink your image with clean, sweeping lines, to create nice smooth curves. There's a lot of movement in this image, so try to draw the main lines, such as the stomach, back, and legs, at one time to give them a smooth shape. Leave some gaps in the lines of the water, to help it look less like a solid object.

ANIMAL BODY SHAPES

Even within the same species, male, female, and juvenile animals all have different body shapes and markings.

With many animals, the males, females, and young will all look different, so do a bit of sketching to see what works best for your character. With Gigi's family, each deer looks different; her father is very solid and strong-looking (2), her mother is very elegant and sleek (1), and Gigi, of course, is still growing, so she is round and energetic (3).

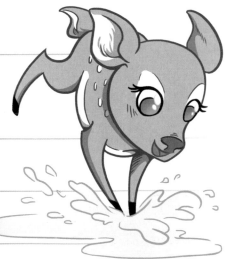

See also

Chibi animals and objects
page 32

4 Fill the character in with your base colors. Using a soft gradient in the eyes gives them depth and draws attention to them. Water is reflective, so add some light highlights to it, to give it a sense of being wet.

5 Add simple, warm shading and color your lines. Use some strokes in your shading to add a bit of texture, suggesting the soft fur in Gigi's ears.

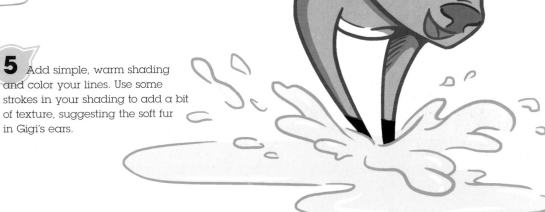

the T-Rex

RAH! RAHHH! RAAAAAAAAARRARAHHH! Stomp stomp stomp! NOM! Diran likes to stomp around, jumping in puddles and eating pretty much everything in sight.

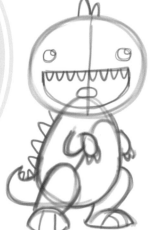

1 Open the drawing app on your tablet device and use the first layer to sketch with your finger or a stylus. Diran is a very simple dinosaur, so use very basic shapes: a big circle for the head, a teardrop-shaped body, and rounded "L"-shaped legs.

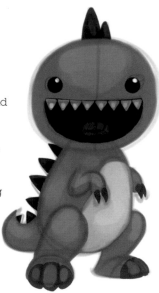

Color Palette

Diran's orange and yellow body, with a hint of red, reflects his bright personality, and his occasional bad mood when he's hungry!

Body

Eyes and mouth **Claws**

2 Make a new layer underneath your sketch and block in the colors. It may help to make separate layers for the main body and mouth, for the red spikes, and for the eyes, teeth, tongue, and claws. Use darker colors for this blocking-in stage. Using the sketch as a guide, add your midtone color to define shapes and show where the light is coming from. It is easier to paint this way when using a tablet device or painting digitally; however, it is the complete opposite when painting with watercolor or using colored pencils, where you work from lightest colors first.

3 One way to blend the blocked-in main colors is to set your brush at a low opacity and gradually build up the color. Add highlights to Diran's skin and claws: notice how the skin "speckles" the light, but on the claws there is a band of light. Add a thin gradient of white to the edges of his left claw and foot, and the end of his tail. This will make it look as though he's fading into the light a little.

Skin patterns

Because paleontologists have only found fossils or bones of dinosaurs, no one really knows what their skin looked like. Because of this, you can try out lots of different designs to make chibi dinosaurs look super cute! Play around with different ideas, such as spots (1), triangular markings (2), or stripes (3), to see what matches their personalities best.

Pebbles is a slightly eccentric dinosaur; a small stegosaurus with a size complex. Pebbles tip-toes around, hiding behind bushes and small boulders to hide her enormous self, when in reality she's only the size of a cat!

PEBBLES
the stegosaurus

Different species

When dinosaurs were around, there were thousands of different species. Rather than just drawing a Stegosaurus (1), why not draw a Triceratops (2) or a Parasaurolophus (3)? Look them up in the library or on the Internet, and break them down into basic shapes for sketching.

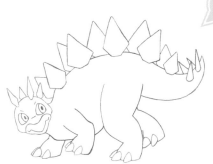

1 Use simple shapes to draw Pebbles' body. A bean shape will create nice curves in the body and legs, which will give the impression of weight. Use diamond shapes to draw the spines. Once you're happy with your basic pose, add in more detail. Try to keep the lines bold so that they're easy to photograph. Grab your tablet device and hold it over the picture—keep your hands steady so that your tablet device's camera can pick up the line work, then take a photo.

2 Copy the photograph into a vector drawing app and create a new layer on top. Using the pen or brush tool, trace the line work onto the new layer. At this point, you can either color the image in the vector app, or you can export the image into a painting app for easier painting. Remember not to include the background layer of your sketch.

Color Palette

Pebbles' body is composed of four colors: green for her body, orange for her spines and eyes, yellow for her mouth, and beige for her tail spikes and toes.

Body

Eyes

3 Make a new layer underneath your lines, and paint in the green body with a solid color. Once you've finished, make sure to lock the layer transparency. Then make a new layer, and fill in the orange parts, then once again lock the layer—repeat for all colors used. Most vector apps have the same tools, but if you're confused at any point, refer to the app's help guide. Locking the layers will allow you to paint on existing colors without going over the lines, which makes adding in shadows and highlights easier. Lastly, use the same "lock layer transparency" on the lines layer to color the lines.

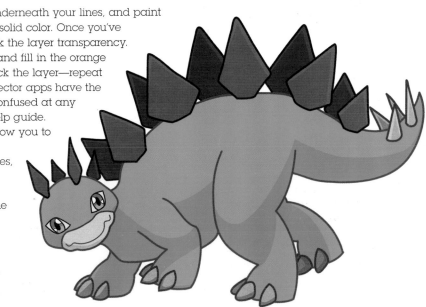

Sweet as candy, cold as ice

ALICE
the Gothic Lolita

Gothic Lolita is the name given to a girlish, frilly, Gothic-inspired Japanese fashion. When drawing a Gothic Lolita make sure you add the correct amount of sweetness to balance her savory-style horror!

Style notes
Gothic Lolita fashion items consist of a top and skirt, or a dress—a "one-piece"—with numerous accessories. A suitable setting would be a charming tea party underneath an amazing Gothic-style tower landmark, with cute cakes and scary drinks.

Color Palette

Dark purples and pastel lilacs make up a dark but sweet color scheme. Pastel pinks and creams add softness to a scheme that could end up too dark. Alice's hair is dark, almost gray, but with candy pinks on the tips of her bunches. She wears cute and scary accessories together, mixing and matching bows and studs.

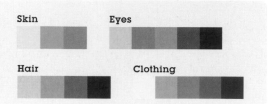

Skin Eyes

Hair Clothing

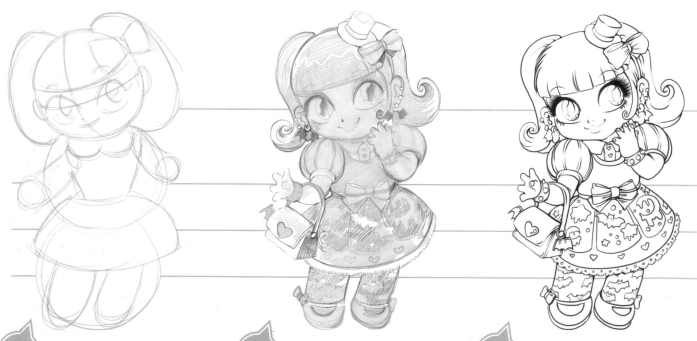

1 A Gothic Lolita's shape is recognizable by the silhouette of her skirt or dress. It should feel like it has bounce, as should her puffy sleeves. Use curved lines and circles to map out her basic shape.

2 Add detail to your sketch with a soft pencil, using an eraser to figure out where your highlights will go. This will ensure that Alice has just the right balance of light and dark. A coquettish expression belies her devilish demeanor, which simmers underneath.

3 When adding your line art, make sure to continue using long, curved lines to keep the overall shape soft. Add details in the way of studs and buttons, and finalize the details on the skirt so that you've got all the information you need for the next step.

DRAWING REACTIONS AND EXPRESSIONS

Tips for drawing extreme reactions, such as surprise, anger, and fear.

Surprise

"A secret admirer? No way!" A happily shocked expression shows Alice's true emotion. She opens her mouth wide to show her tiny fangs. Add symbols, such as sparkles, to emphasize the awesomeness of the gift she's received.

Anger

Alice cannot hide her base feelings. When angered, she literally trembles and quakes with rage. Her eyes turn quite devilish and veins appear on her head.

Fear

Alice hates loud noises, and will shy away from anything that she doesn't like. Note how her hairstyle goes from curly to jagged—even the smallest details can emphasize expression.

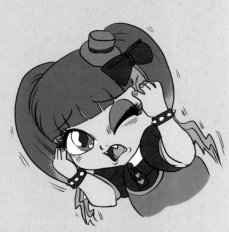

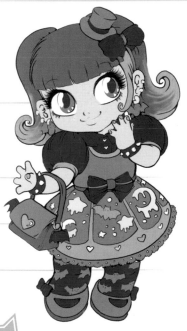

See also

Dressing your chibi
page 30

4 Using a complementary color scheme—in Alice's case, purple, pink, and gray—add in your flat colors. Put in some areas of candy cream color to make certain details pop out and add a bit of variation.

5 Though Gothic Lolita girls can be scary, they're still super cute. Make Alice's eyes really deep and shiny with lots of shade and highlights, and add glittery highlights to everything, including her skin, shoes, dress, and hair accessories. If drawing on a computer, play around with digital filters and different brush settings for lots of variation on the sparkles; but, if not, try using metallic glitter pens or white ink.

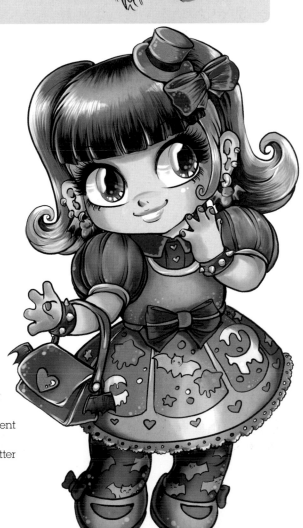

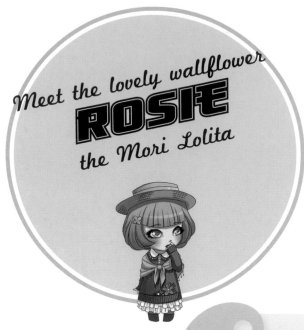

Meet the lovely wallflower

ROSIE

the Mori Lolita

Shy, sweet Mori Lolita Rosie absolutely adores nature and loves to dress so that she matches the world around her. Her favorite ways to pass the time are planting flowers in the garden and drinking delicious fruit tea.

Style notes
Mori Lolita is a Japanese fashion trend that draws on comfortable, natural-looking styles and colors for inspiration. Long, layered skirts, shawls, and straw hats are some of the most common items of clothing worn by Mori girls.

Color Palette

Being a nature lover, Rosie is made up of colors that you'd find in a meadow or forest. Greens, browns, light blues, and pinks are the perfect palette for this delicate flower.

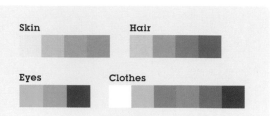

Skin

Hair

Eyes

Clothes

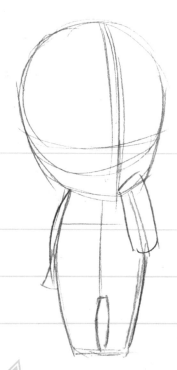

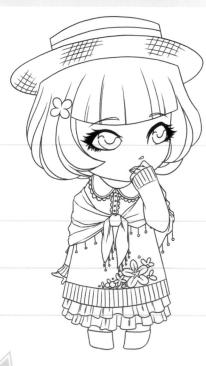

1 Map out the body using simple shapes to help you capture Rosie's pose. She's very shy and uncertain, so try turning her toes inward to face each other and keep her arms tucked close in to her body to make her look extra cute.

2 Sketch in clothes, hair, and features over the top of your pose. Bobbed hairstyles are a very popular style among Mori Lolita. Make the hair look soft and bouncy with loose, curving strokes to create lots of volume.

3 When you draw in your line art, don't be afraid to add in a few more details or correct mistakes that you made in your sketch. Your pencils are only to give you a rough idea of what goes where, so if you want to improve something, like the knot of her shawl, or add a few more lines to the frills on her skirt, now is the perfect time to do it.

THE WAY YOU WEAR YOUR HAT
Tips for drawing hats from all angles.

Hats can be tricky to draw sometimes because they hide a good amount of the head underneath. Try drawing the head of your character first, then sketch the hat over the top so that it sits on the widest part of your circle. Shown here are a side view (1), three-quarter view (2), and view from below (3).

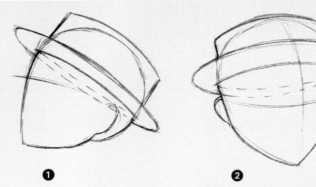

❶ ❷ ❸

See also

Creative coloring page 26
Dressing your chibi page 30

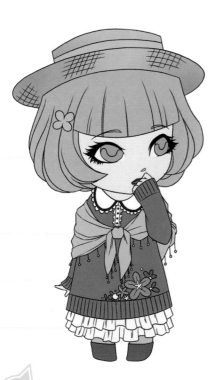

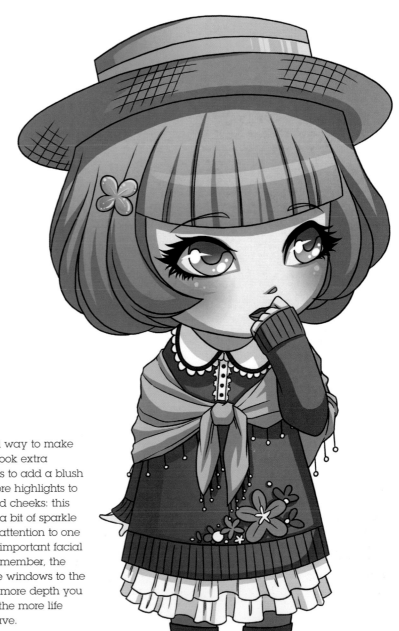

4 As well as using different hues of color, see what you can achieve by changing the saturation of your colors. Rosie isn't the sort of girl who likes to stand out from a crowd, so duller greens, pinks, and blues suit her better than bright, attention-grabbing shades.

5 A good way to make characters look extra appealing is to add a blush or a few more highlights to the eyes and cheeks: this gives them a bit of sparkle and draws attention to one of the most important facial features. Remember, the eyes are the windows to the soul, so the more depth you give them, the more life they will have.

It's the end of their senior year at high school, so this lovely couple is going to the prom. Pamela has made a real effort to look picture-perfect with a formal, but pretty hairstyle and a cute dress with a skirt that swishes well on the dance floor. Peter is also looking very dapper.

Style notes

If this couple wants to have a shot at becoming the prom king and queen, they need to look immaculate and well coordinated. Their outfits complement each other perfectly. Pamela's white dress and shoes are set off by Peter's ruffled wing-tip shirt, and they both have pink and lilac accessories. The flower motifs are repeated in Pamela's hair, dress, shoes, and wrist corsage. Peter wears a similar buttonhole.

Color Palette

They are a vibrant and pretty pair, so although their main outfits are in black and white, their accessories, hair, and eyes provide a wonderful contrast. They are young, so their skin tones are warm and healthy. There are dark and light shades of color, because pencils can be layered on thinly or pressed hard to saturate the paper.

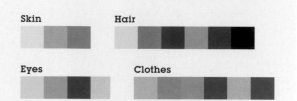

| Skin | Hair |
| Eyes | Clothes |

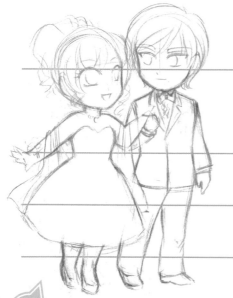

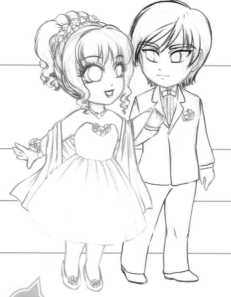

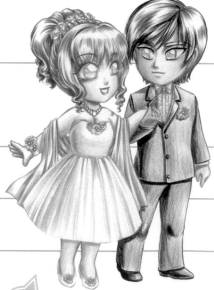

1 If you are working with colored pencils, be light and delicate in your initial sketches because you do not want to erase too many lines from the paper or leave indents in it that will affect any smooth shading you want to lay down. Pick a very light color, such as pale pink, to set out your rough guidelines.

2 When you have a rough idea of the main components of the drawing, add detail with stronger outlines. Use darker shades of the appropriate colored pencils and sharpen them as you go so that you can define details like the ruffles and the curls of the hair. Do not be tempted to use a normal pencil or black pens to outline because these will deaden the piece.

3 Use the same colors that you outlined with to fill in some basic shading. Start by using very light pressure to give a thin layer of color and to blunt your pencil end. This will make shading faster and more even. Press harder for a darker, more saturated look near the outlines. Try to match the direction of your pencil strokes with the contour of the area you are shading: don't sharply change direction halfway though.

DRAWING COUPLES
When drawing characters interacting, make sure to keep the proportions consistent throughout.

The key thing to remember when drawing interacting characters is to keep their relative heights and body proportions consistent in all poses. Use your fingers (or a ruler) to measure the size of the head relative to the rest of the body, and position them at the right heights to each other for any pose. Even if you get that right, it can also be tricky to draw the characters interacting. Look at real life couples and see how they hold each other and dance (1), so you see what the comfortable limits for the human body are (2) and how close they can get (3). Draw full outlines of both people first, even the parts which are unseen or covered by each other.

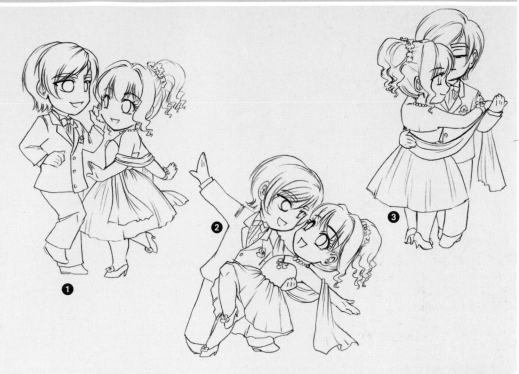

See also

Creative coloring page 26
Dressing your chibi page 30

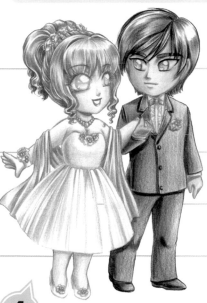

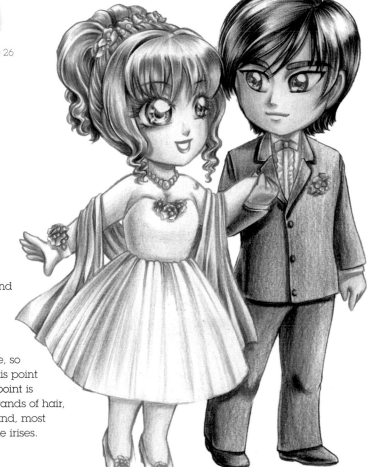

4 Add depth and warmth to the picture by shading with pale, thin layers of lighter colors. Use yellows and oranges to add a healthy glow to the skin. Some blues complement the dark tuxedo suit well and hint at the blue-white dress nearby, casting a slight glow. Warm golds are used in both hairstyles to increase the shine and color saturation.

5 Sharpen your pencils and use darker shades to add definition to your outlines. They would have been softened by all the coloring and shading you have done, so adding darker outlines at this point works well. A sharp pencil point is very effective at defining strands of hair, small details of the pearls, and, most importantly, the details of the irises.

AVERY
the chef

Avery is a rarity: a modest and humble chef who is more comfortable baking alone than he is in crowded kitchens. His quiet disposition is made up for with his flamboyant—and delicious—cupcakes!

Style notes
When it comes to color-coding his outfit, Avery uses food as his inspiration. In this instance, he's decided to go for a "berries and cream" look to match his strawberry cupcakes.

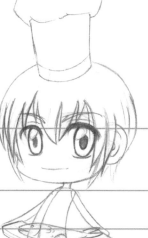
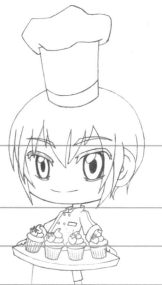
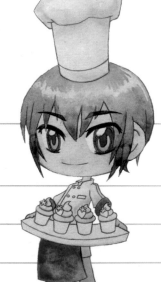

1 On inexpensive printer paper, draw simple shapes for a rough head, body, chef's hat, and tray. You'll want to include the chef's hat at this stage because it is nearly a whole third of Avery's body size! Draw a cylinder and top it with three uneven squares.

2 Because you're drawing a chibi, you don't need to worry about perfect human anatomy. Instead, because we're simplifying shapes, think about the shape of his body rather than where the bones and joints would go. Notice how his arms and legs curve gradually instead of bending at a definite point. Start to add hair, eyes, and detail to his head and hat, and think about what to have on his tray.

3 Avery needs some clothes. Draw these over his body and erase the construction lines. If there are any changes you would like to make to your drawing, now is the time to make them. Notice that, on this sketch, Avery's eyes have changed, along with the contents of the tray. Once you're happy with the sketch, use a sheet of tracing paper to transfer it to watercolor paper (see Trace and Transfer, page 115).

4 Apply masking fluid to any areas you want to keep completely white, such as the jacket buttons and eye highlights, and wait for it to dry thoroughly. Using watercolors, dampen an area to be colored with a little water and drop your paints onto it, starting with light colors and working to the darker colors. Wait for each color to dry before adding another, to prevent colors bleeding into the wrong area.

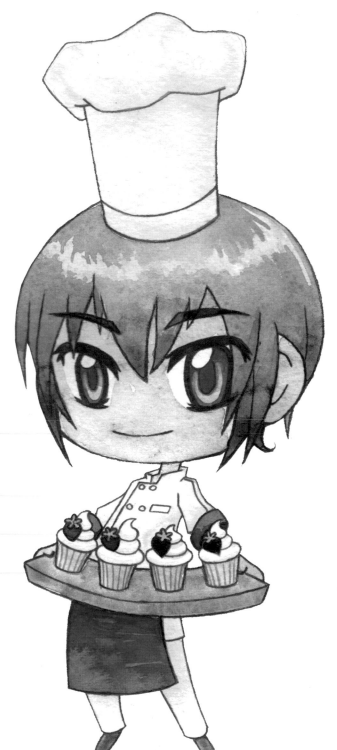

WATERCOLOR TECHNIQUES
Watercolor paints are possibly the most accessible and cheapest medium you can buy, and you can get some fantastic effects with them.

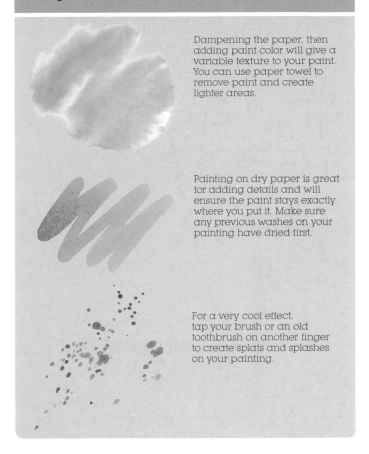

Dampening the paper, then adding paint color will give a variable texture to your paint. You can use paper towel to remove paint and create lighter areas.

Painting on dry paper is great for adding details and will ensure the paint stays exactly where you put it. Make sure any previous washes on your painting have dried first.

For a very cool effect, tap your brush or an old toothbrush on another finger to create splats and splashes on your painting.

Color Palette

Avery likes to stick with traditional chef's whites, but a hint of color on his apron, the cuffs of his jacket, and his hair make him immediately recognizable.

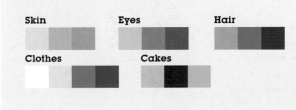

Skin Eyes Hair

Clothes Cakes

5 Add any final details with your paints on dry paper—as opposed to damp, as before—in particular the eyes and the cupcakes. This technique is great for adding detail to your watercolor painting, whereas paint on wet paper is best for large washes of color. Finish by removing all masking fluid and enhancing your line art with colored pencils.

See also

Traditional media page 12

Lizzie is the captain of her amateur baseball team. She's a player, coach, and manager all rolled into one, and believes in her teammates' hard work and enthusiasm. She may work her teammates hard, but always makes sure that a hard day's training is rewarded.

Style notes

Lizzie's uniform is based on a road design because her team doesn't have its own ballpark, and is usually invited to practice with other teams. Lizzie wants to reflect her team's "homelessness" by always playing in a road uniform, until they get their own ballpark.

Color Palette

Lizzie's road uniform makes her easily distinguishable from other teams, who wear plain white home uniforms. It's a pale turquoise, with blue trim, and a splash of eye-catching red is introduced in small areas in her helmet, gloves, and shoes.

Skin	Eyes	Hair

Clothes	Bat

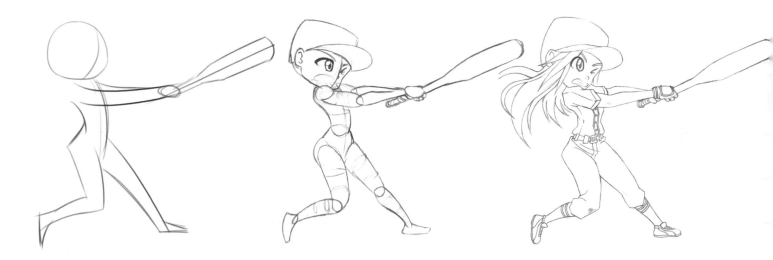

1 As you're going to be drawing a dynamic pose, start by sketching with flowing lines to get the rough pose right. Look at photos of baseball players in action, and copy the rough silhouette that their bodies make with your flowing lines. At this stage, draw onto some inexpensive printer paper instead of your artists' drawing paper, because you may need to erase some lines.

2 Once you are happy with the rough pose, start to add simple shapes to fill out the body. Don't worry about adding clothes yet. Focus on the pose and anatomy first, and the clothes will be easier to add later.

3 Now it's time to add the clothes and the hair. You may find it easier to scan your last sketch and print it out very faintly. You will still be able to see the construction lines, but they won't be as distracting. Once you're happy with the lines, it's time to transfer them to your watercolor paper.

TRACE AND TRANSFER
First get your drawing right, then transfer it ready for painting.

Watercolor paper can be expensive to use, and there's nothing worse than erasing pencil lines only to find pencil indentations on your paper. Your paint could end up pooling in these lines, which is something you want to avoid. To prevent this, sketch onto inexpensive printer paper until you are 100 percent happy with your drawing. Using tracing paper, trace over your sketch, then, flipping it over, scribble on it with the side of an old pencil to transfer the lines to your watercolor paper. Your drawing will be faintly outlined on your watercolor paper, perfect for painting over.

See also

Traditional media page 12
Dynamic drawing page 22

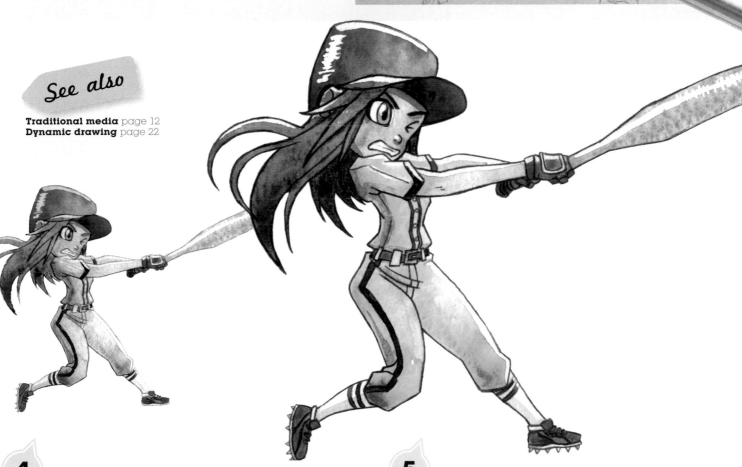

4 Transfer your sketch to watercolor paper (see Trace and transfer above). Using masking fluid and an old brush rubbed in soap (to keep the masking fluid from ruining the brush), mask out any areas you want to keep completely white. When dry, choose an area of the drawing that will be all one color, and dampen that area with your paintbrush. While still wet, carefully dab your chosen watercolor onto the paper, allowing it to pool in areas where the color should be dark, and using paper towel to soak up moisture where it should be light. Allow the area to dry before starting on another area. Repeat for the entire painting.

5 When you've finished painting, wait for the paint to dry fully, then remove the masking fluid. You may notice a few areas where you've gone over the lines, but don't panic; this can be cleaned up with a little white paint. Using colored pencils, go over your pencil lines to tidy the picture up, matching the line color to the paint next to it.

Henwin may be a pig, but she's also a lady, and a lady likes to be clean. Nothing beats the feeling of being freshly out of the bath, even if she has missed a spot or two. Henwin likes to keep herself as presentable as possible, but she just can't resist a good mud puddle!

1 Because Henwin has such a simple shape, all you need to draw her body out is a simple circle. Carry the shape around to make a rough triangle to show where her face is pointing, and add in a few simple marks for her feet and tail.

Changing poses with very simple characters
Just because you're using simple shapes doesn't mean that your characters will lose personality. Use curved lines to help visualize where to add in facial features, and remember to keep it simple and cute.

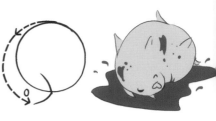

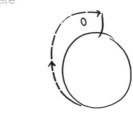

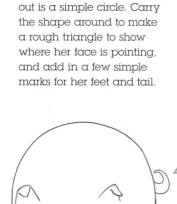

2 With your basic shape established, draw in the eyes, ears, and nose. Slightly folding the tips of the ears and using different eye shapes can help add character. Because this is quite a simple image, we're going to use colored line art to add interest. We know Henwin is pink, so use a slightly darker shade to line with, and make the eyes darker still.

3 Using the wand tool, select the space inside your line art. Then, create a new layer for colors and use the fill tool to add in the base colors. Lock the pixels on the layer so that you don't accidentally color outside this, and add in details such as the patch on Henwin's stomach, hooves, nose, and the highlights. To break up the pink, use a different color for shading, such as blue. You can put your shading in on a separate layer and then use the hue slider to try out different colors to see what works best. Add in details, such as the splash of mud on her back, for added character.

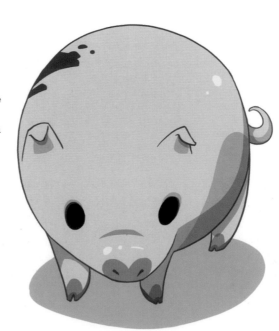

Color Palette

Henwin is a classic pig, which means that she's pink all over. However, this doesn't mean that her design is boring. By giving her small patches of darker pink and soft, brown eyes, it's easy to keep her looking cute and appealing.

Body

Eyes

When it comes to hanging around all day, there's no one better at it than little Jock. Forget chores or work, for Jock it's all about chilling out.

Color Palette

There are hundreds of species of monkey out there, all of which look very different. There are red monkeys, white monkeys, and even blue monkeys! A lot of spider monkeys, like Jock, are brown and gray with gold arms and legs, which makes for a rather cute character design.

Body

Eyes

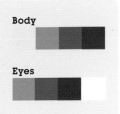

1 Sketch out Jock's head and body first. Jock's torso is a bent bean shape because he's sitting down. If you have trouble figuring out where to place his arms and legs, try drawing a line over the curves of the bean to show the center of his torso, then draw circles in where his arm and leg join at the shoulder and hip.

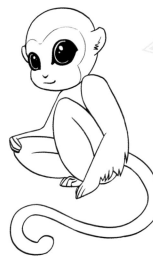

2 You may find it useful to use a photo reference of how monkeys sit. Sketch in Jock's face and don't forget to add in some scruffs of fur along his body. If you make sure that you're completely happy with your sketch before you add in your line art, you'll save yourself a lot of time with erasing and fixing it later. Line neatly over the sketch, using a variety of thicknesses to keep the image interesting.

Looking at real animals

When drawing animals it's useful to look at real-life references. This way you can look closely at the way their legs bend or observe the shape of their faces and so draw them accurately. Monkeys have a very human shape, but they also have long arms and legs, as well as a very flexible tail, which can sometimes make them move in unpredictable ways.

3 Use a hard-edged brush to block in the basic browns of Jock's coat on a layer beneath your line art. Then lock the pixels on your coloring layer so that you can't color outside of what you've done. Using a soft-edged brush, add in the gold on Jock's arms, legs, and tail, and use a hard brush afterward to add in texture for his fur and a few brightly colored freckles. Change your brush color to purple and make a new layer. Change the layer filter to a multiply style and, using a hard brush, add in your shading. You can use this in places to make short spikes of fur to add texture. Add shading beneath to show where he's sitting and suggest where his tail curls away from the floor.

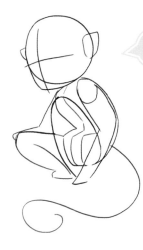

Twenty years ago Rossum was the most modern robot around. However, over the years, he's found himself frequently overlooked, and left to his own devices with the rest of the forgotten objects on the shelf.

1 Rossum is made of two very basic shapes, a square and a cylinder, so block these in and add in rough lines where his arms and legs should be. Start to add detail to the sketch—it doesn't matter if it's rough at this stage. Try adding vents, big buttons, panels, and oversized aerials to give him a retro look, because not all technology was as sleek-looking as it is today.

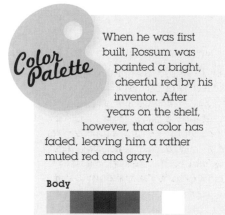

Color Palette

When he was first built, Rossum was painted a bright, cheerful red by his inventor. After years on the shelf, however, that color has faded, leaving him a rather muted red and gray.

2 Once you've finalized your design, add in your line art, making it thicker in places to give depth. Then add in your colors. If you're drawing with pens and pencils, work out your color scheme first. If you're using a computer, use the wand and bucket tool to fill in sections with color; then, once it's blocked in, you can play around with how different colors look until you're happy with the result.

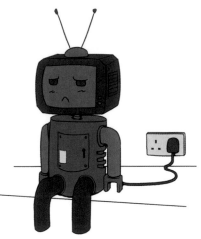

Body

3 A great way to add texture to your images is by using photographs. You can download textures that are free to use, or use a camera to make your own. Find textures that match your image—in Rossum's case, television static and old metal—and layer them over your image. Try using different digital filters to get the right look. Next, add in your shading. Using the same shading layer, you can include details, such as dents and scratches. Add in a few highlights, but not too many, because Rossum is pretty faded and dusty with age. Don't forget to add some shading beneath him, to show where he's sitting.

1

Making bulky cute

Simplifying large, bulky objects, such as televisions, may seem daunting at first (1); but, once you get the hang of it, it's no more difficult than simplifying people or animals. Big objects don't appear to have the cute effect; but, if you use slightly curved, freehand lines (2) instead of using a ruler, and simplify or remove smaller details, such as panels and buttons, all you'll need to finish is a few shiny highlights and chunky shading (3) to make it really chibi.

2

3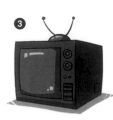

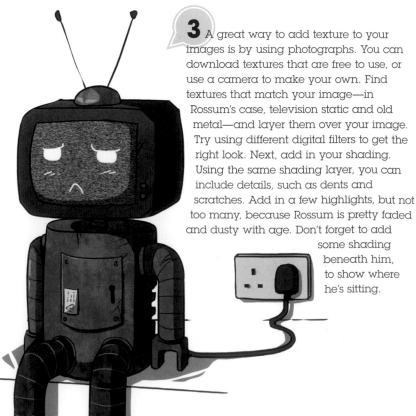

Brand-new off the production line, Sulla is excited and ready to help. Give her any job and she'll have it done in minutes.

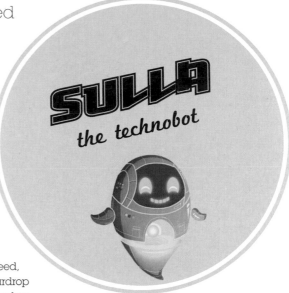

SULLA
the technobot

Color Palette

Because Sulla is so modern, her exterior is dirt and scratch free. She's a light gray in color, which is very slightly blue to stop her from looking too dull. It also reflects the blue of her electronics and power source.

Body

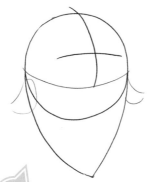

1 Sulla's shape is very basic indeed, so start with a circle and add a teardrop shape beneath. Mark in the lines for her face, just as you would for a human or animal, because this will help you place her eyes and mouth later.

2 It doesn't matter if your sketches are very rough at this point, but mark in where most of your details will go. To keep Sulla looking light, modern, and interesting, we're not using line art this time. Using your sketch, block in her shape with pure colors; then, using an eraser, rub out the very fine lines that add detail, such as her panels, buttons, and joints. Keep them curved to make her look three-dimensional. By doing this, you're using your eraser in exactly the same way that you would have drawn in the line art.

Robot expressions

Sulla's face is a pixel-based display, so her expressions are similar to the text-based emoticons that you use when chatting to your friends online. A smiley face denotes happiness (1), round eyes and a triangular mouth implies surprise (2), while two lines for eyes suggest Sulla is asleep (3).

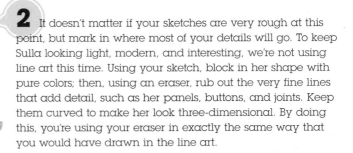

❶

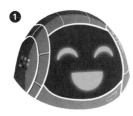

❷

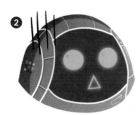

❸

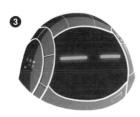

3 Using a very soft brush and gradient tool—or a soft pencil if you're drawing on paper—add in the basic shading to give you an idea of where the light source is coming from. In this image, there are two: the main one from Sulla's power source; and the second from the right-hand side. Using a hard brush—or the hard edge of a pencil—add in some solid shading to give a more certain idea of the light source. Add shadows a little beneath her to give the sense of her hovering above the ground. Add in a few highlights to show how shiny she is.

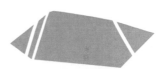

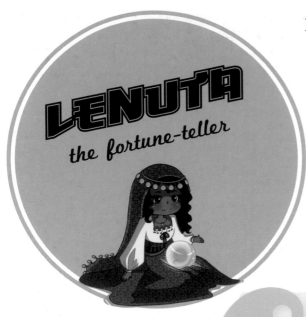

Lenuta's always had a gift for the supernatural, and telling people's fortunes is one of her favorite pastimes. Whether it's palmistry, cards, or reading from her crystal ball, she can usually be found day-dreaming, lost in her visions of the future.

Style notes
There are many traditional images of how fortune-tellers look, but don't let that hold you back from being creative. Try using different patterned fabrics, colors, and lots of pretty jewelry to make your character truly unique.

Color Palette

Purple is a traditional color for fortune-tellers, and it offsets Lenuta's dark skin nicely. Gold or yellow is a complementary color for purple, so accents and jewelry in this color will look striking. The small blue accents—analogous colors to purple—complement the light coming from the crystal ball and tie the whole image together.

Skin

Eyes

Clothes

Crystal ball

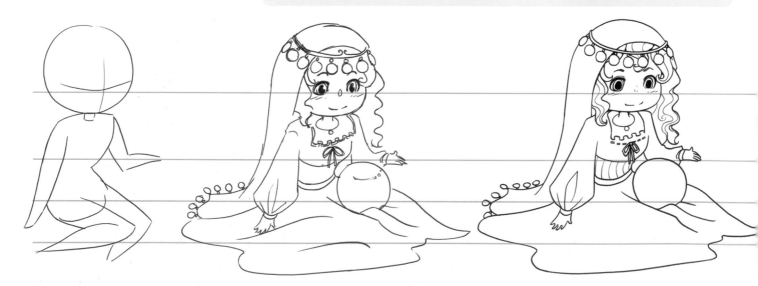

1 Using very basic shapes, sketch out Lenuta's form. Even though a long skirt conceals her legs, it's important at this stage to still draw them in, because it will help you to ensure that her pose is right, and that she's sitting comfortably and realistically on the floor.

2 With your basic figure in place, draw everything in more detail. Here's where you get to experiment with clothes, jewelry, and expressions. Make sure that the skirt drapes over the legs accurately: use lines of fabric to suggest the legs beneath.

3 Use a brush, pen, or dark pencil to add in your line art. Make the lines thicker in the corners and areas of close line art to add depth and a suggestion of shadow. Don't be afraid to vary your line thickness to make it interesting.

DRAWING PATTERNS BY HAND

Drawing repeating patterns by hand is great fun.

If you've ever had a notepad near you when you're on the phone, this is probably something you've done before. Practically any shape can be repeated into a pattern. Try drawing one shape (1), then a couple more around it to make a triangular (2) or diamond arrangement. Then, just repeat it (3). This works for both very simple shapes and detailed ones, so have fun experimenting.

See also

Dressing your chibi
page 30

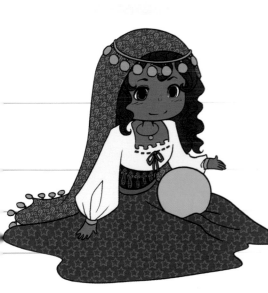

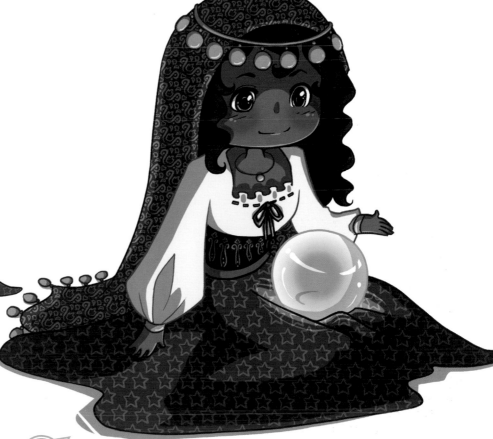

4 A fortune-teller is always theatrical, so Lenuta's clothes are exotic and beautiful. Once you've put down your base colors, use patterns over the top to add detail and interest to the fabric: on a computer, you can do this with a new drawing layer and digital filters; on paper, you can do this with metallic gel pens, paints, or inks.

5 This is the step where everything comes together. The light in this image is coming from the crystal ball, so, with that in mind, add in your shading, then the highlights in Lenuta's lap, where the light is strongest. Add a happy blush to her cheeks and lines of light to the edge of her face, lower lip, cheeks, and jewelry. Don't forget to make her eyes deep and sparkly by adding lots of layers of color and highlights.

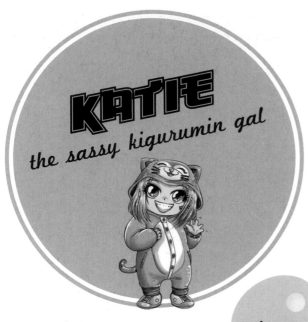

Kigurumin are party animals; but, although they party hard, they relax hard, too! When drawing a kigurumin, be careful to get the shape right to clearly show there is a person inside the costume.

Style notes
Kigurumin is a name given to a person who wears a kigurumi (a "kigu," or "onesie"), a soft, baggy, pajamalike costume with a face on the hood that is super-comfortable and easygoing. Everyone smiles when they see someone partying in a silly kigurumi, and it raises the bar for fun.

Color Palette

Inspired by pretty pastel cakes and doughnuts, this color scheme encompasses a happy pink and a soft, creamy yellow. The green sneakers add a bit of quirkiness to the color scheme. A purple tone for shading complements the pinks.

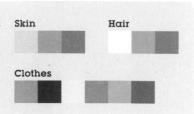

Skin Hair

Clothes

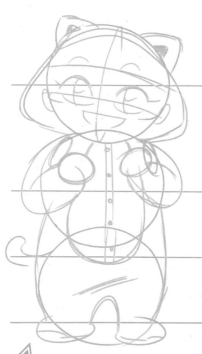

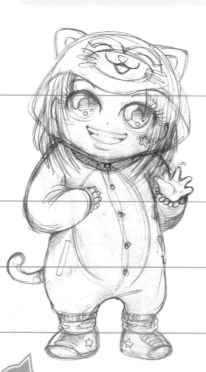

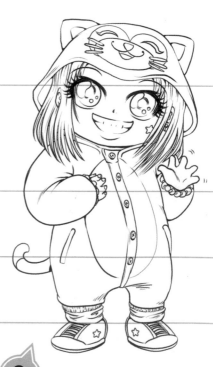

1 Soft and baggy, the shape of a kigurumi should be puffy and feel like it has some bounce. To evoke this, draw your figure roughly with circles and broad, curved lines.

2 Try drawing a lively waving pose to hint at Katie's outgoing personality. Use swooping gestures with your lines for a soft, easy feel.

3 Draw in your line art using a number of pens with different sizes of nib to add weight, depth, and interest to the character.

DETAILS AND EXPRESSIONS
Expressing yourself in kigurumin style!

Eating
Nobody cares how much you eat in a kigurumi! That sugar is needed to party. Try matching the color scheme of the sweets to that of the character.

Late nights
Too many late nights mean your character is sure to be tired sometimes. A pair of dark shades will help your character hide from the morning sunlight, and a strange expression shows just how she feels.

Embarrassment
The hood can be pulled down to obscure your character's expression; however, the mood is given away by the gesture of the mouth and possibly some blushing. For a surreal and comedic touch, draw the character on the hood of the kigu with an expression to match that of your main character.

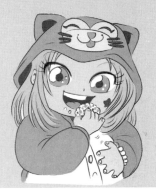

See also
Dynamic drawing page 22
Dressing your chibi page 30

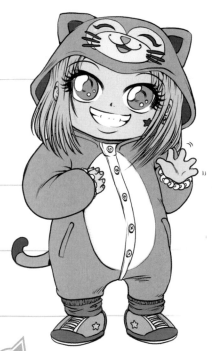

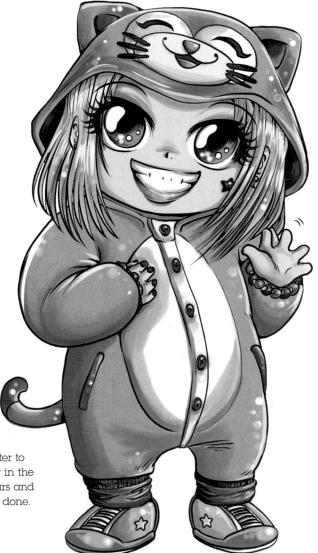

4 Plan your color scheme before you start to add in your flat colors. An analogous scheme like Katie's will use three colors that are next to each other on the color wheel, one primary color and the two tertiary colors on either side. By working out your colors on the color wheel first, you know that your scheme will work well.

5 Plan your light source and add in shading. Then comes the best part: adding the details. Include lots of different shades in the eyes to make them deep and sparkly; then, using white highlights, add sparkly glitter to Katie's kigu and hair. Color in the small items, such as the stars and bracelet beads, and you're done.

Stalk the shadows with
TSUBAKI
the ninja

An umbrella maker by day and a ninja by night, Tsubaki roams the rooftops of old Kyoto using darkness as his disguise, and a quick shuriken to fell his foes.

Style notes

Ninja typically kept their faces hidden, and their clothes tightly wrapped at the ankles and wrists so that they wouldn't get tangled up when running and jumping. Tsubaki keeps himself in great shape, so he's always ready to fight his enemies. He looks his best in athletic poses.

Color Palette

Nighttime is when Tsubaki feels most comfortable because his clothes allow him to move around in the dark without being seen. Dark, desaturated purples and tanned skin contrast well with the light chrome gray of his blades and throwing stars.

Skin

Weapons

Clothes

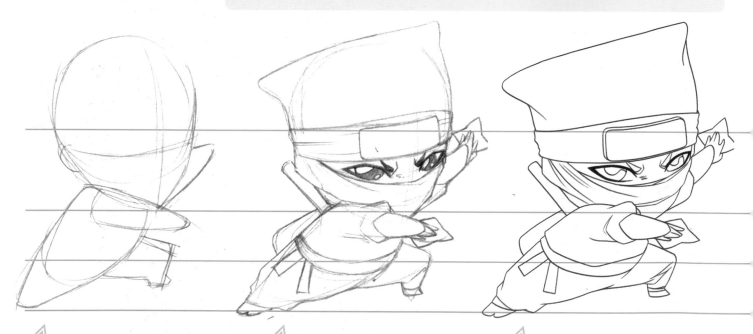

1 When you are sketching out Tsubaki's pose, try to get the balance of his weight established from the very beginning. He's leaning all his weight forward onto his left leg so that his right is free to stretch out behind him and steady his pose. He should look like he's ready to spring into action at any moment!

2 Start adding in your details, paying particular attention to the stretch and pull of the fabric. Tsubaki's clothes are wrapped tight to keep them out of his way, and drawing in folds that follow the direction of his pose will help to make them look natural.

3 Now that your sketch is neatened up, draw your line art. Filling in the outline of Tsubaki's eyes will give him bold, thick eyelashes that stand out against the rest of his design and stop his eyes from being overpowered by the dark colors you will be putting in later. Nothing escapes this ninja's piercing gaze!

WEAPONS
A brief introduction to ninja weapons.

Ninja didn't just fight using shuriken and martial arts. They often had a wide range of different weapons at their disposal, such as tekagi-shuko and neko-te (hand claws, 1), kusarigama (chain-sickle, 2), and kunai (throwing knives, 3).

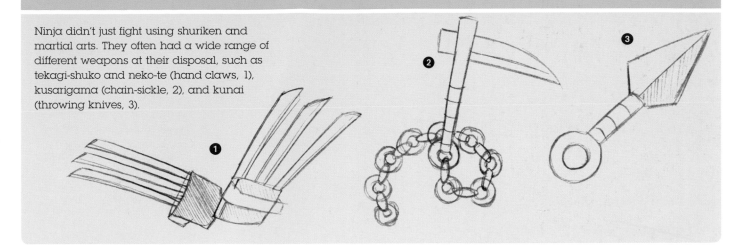

See also

Dynamic drawing page 22
Chibi animals and objects page 32

4 Time to lay down some flat colors. Because there's so much dark purple in Tsubaki's design, you'll want to break it up with the occasional section of another color to add some variety to his appearance. Making his headband, his bracers, and his weapon bag a slightly deeper shade will add some variation to the overall effect.

5 Use your shading to add even more variety and direction to Tsubaki's clothing. A few gradients here and there will really add to the richness of the colors. For the metal of his headband and his throwing stars, use a few light gray stripes of different widths to create a glinting metallic sheen.

INDEX

RESOURCES

All foreign websites listed have English versions and ship to the United States.

Software and hardware

- **Photoshop, Illustrator, Flash:** www.adobe.com
- **Manga Studio:** manga.smithmicro.com
- **OpenCanvas:** www.portalgraphics.net/en
- **Painter:** www.corel.com
- **Artrage:** www.artrage.com
- **GIMP:** www.gimp.org
- **Graphics tablet:** www.wacom.com
- **Mac equipment:** www.apple.com

Traditional art supplies

- **Letraset:** www.letraset.com
- **Copic:** www.copicmarker.com
- **Deleter:** www.deleter.com
- **Dinkybox:** www.dinkybox. co.uk

Fonts, brushes, and stock images

- **DaFont:** www.dafont.com
- **Blambot:** www.blambot.com
- **Fontspace:** www.fontspace.com
- **Photoshop & GIMP Brushes:** www.obsidiandawn.com
- **Stock Photos:** www.sxc.hu www.scott-eaton.com www.artmorgue.com

Online art galleries

- **Deviantart:** www.deviantart.com
- **ImagineFX:** www.imaginefx.com
- **Pixiv:** www.pixiv.net
- **Society 6:** www.society6.com
- **CG Society:** www.cgsociety.org

Blog and website hosting

- **Blogger:** www.blogger.com
- **Livejournal:** www.livejournal.com
- **Rydia:** www.rydia.net
- **Tumblr:** www.tumblr.com

Manga publishers

- **Tokyopop:** www.tokyopop.com
- **Seven Seas:** www.gomanga.com
- **Self Made Hero:** www.selfmadehero.com
- **Slave Labor Graphics:** www.slgcomic.com
- **Sweatdrop Studios:** www.sweatdrop.com

Webcomic hosting

- **Smack Jeeves:** www.smackjeeves.com
- **Bento Comics:** www.bentocomics.com

CREDITS

We would like to thank the following for supplying images for inclusion in this book:

Designs Stock, Shutterstock.com, p.36bl
Ewa Studio, Shutterstock.com, p.78tr
Hironai, Shutterstock.com, p.84tr
Horimono, Shutterstock.com, p.124tr
Isselee, Eric, Shutterstock.com, pp.80tr, 86tr, 100tr
Kokhanchikov, Shutterstock.com, p.50tr
Man, Kenneth, Shutterstock.com, p.72tr
Pawlowska, Edyta, Shutterstock.com, p.56tr
Popov, Andrey, Shutterstock.com, p.112tr
Prudkov, Shutterstock.com, p.46tr
Song, Tang Yan, Shutterstock.com, pp.11, 41
WilleeCole, Shutterstock.com, p.102tr

We would also like to thank the following artists for their contribution:

Carly Matlack, http://flavors.me/ligernekoka
Heather Sheppard, http://dinobot.carbonmade.com
Kit Buss, anemonetea.deviantart.com
Laura Watton-Davies, http://pinkapplejam.com
Nina Serena, ninaserena.deviantart.com
Sally Jane Thompson, www.sallyjanethompson.co.uk
Sammi Guidera, http://sammiguidera.com
Sonia Leong, www.fyredrake.net

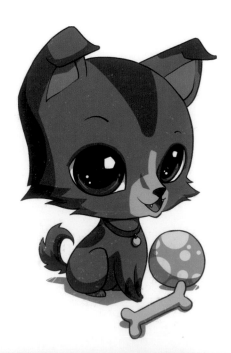